THE PURE JOY OF BEING

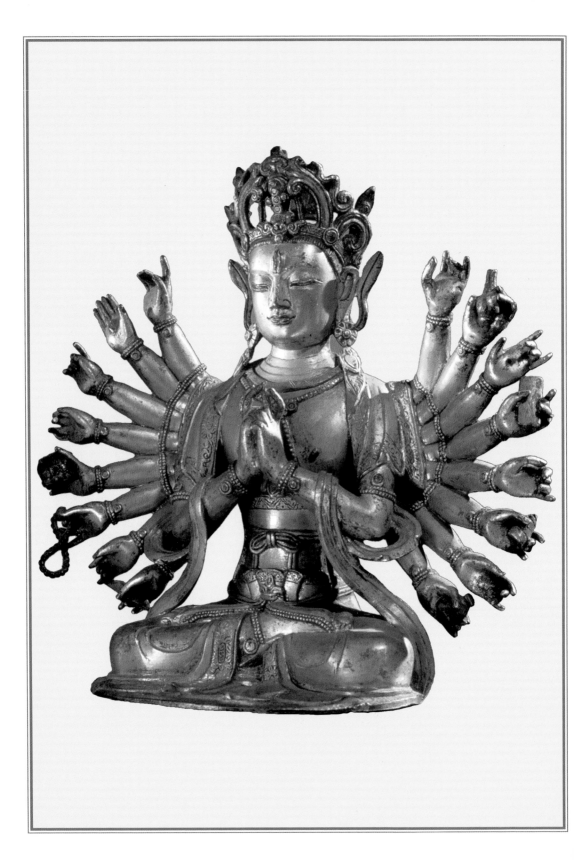

THE PURE JOY *of* BEING

AN ILLUSTRATED INTRODUCTION TO THE STORY OF THE BUDDHA AND THE PRACTICE OF MEDITATION

Fabrice Midal

Foreword by
JACK KORNFIELD

SHAMBHALA
Boulder
2017

I would like to dedicate this book to Frédéric Lenoir, who gave me so much through his work on inventing new ways to awaken our hearts, with his desire to open up spiritual realms to so many great witnesses, allowing words of wisdom to be heard in today's world, and would like to thank him for his unwavering friendship.

Shambhala Publications, Inc.
4720 Walnut Street
Boulder, Colorado 80301
www.shambhala.com

Text © 2017 by Fabrice Midal/Leduc.s Éditions
Illustrations © 2004, 2017 by Robert Beer
Design © 2017 by Eddison Books Limited

Published by arrangement with Eddison Books Limited.
www.eddisonbooks.com

9 8 7 6 5 4 3 2 1

First U.S. Edition
Printed in Serbia

✿ Shambhala Publications makes every effort to print on recycled paper. For more information please visit www.shambhala.com.

Distributed in the United States by Penguin Random House LLC and in Canada by Random House of Canada Ltd

Library of Congress Cataloging-in-Publication Data

Names: Midal, Fabrice, 1967– author.
Title: The pure joy of being: an illustrated introduction to the story of
 the Buddha and the practice of meditation / Fabrice Midal; foreword by
 Jack Kornfield.
Other titles: Is meditation only for Buddhists?
Description: Boulder: Shambhala, 2017. | Originally published under title:
 Is meditation only for Buddhists? London: Eddison Books Limited, 2017. |
 Includes bibliographical references and index.
Identifiers: LCCN 2017003998 | ISBN 9781611804843 (hardcover: alk. paper)
Subjects: LCSH: Meditation—Buddhism. | Gautama Buddha.
Classification: LCC BQ5612 .M54 2017 | DDC 294.3/4435—dc23
LC record available at https://lccn.loc.gov/2017003998

CONTENTS

Foreword *by Jack Kornfield*

This beautiful book is a transmission of wisdom, compassion, and inner awakening, offered through poetic words and a stunning selection of the finest Buddhist art. Art is one of the most unique expressions of our humanity. Since the first cave paintings 100,000 years ago, the works of theater, poetry, sculpture, painting, and music have brought us closer to awe, beauty, and the mystery of life.

The Buddhist art depicted here offers a window into the transformative teachings that have inspired the lives of a billion people over thousands of years. The story of the Buddha is one of the world's most well-known and beloved accounts. It tells of a human being confronting and overcoming the forces of fear, confusion, and anger with wisdom and compassion—and then it demonstrates the miracle of transmission, teaching how the awakened heart in one human being can touch others and inspire in them the same powerful transformation.

Through these pages, Fabrice Midal follows these teachings and their transformative power, as they move through—and are enriched by—the civilizations of Asia, from India and China to Japan and Tibet, and from southeast Asia to Afghanistan and Korea. Filled with images of bodhisattvas and awakened beings, these pages demonstrate the possibility of freedom that has been carried and celebrated by generations.

The teachings and wisdom here are universal:
- *All things are impermanent, evanescent, always changing. They can be loved and tended—but do not cling to them, for they will not last. Wisdom and ease arise when you accept this truth.*

- *Human life entails suffering as well as joy. Suffering is increased with greed, hatred, and ignorance. Suffering is diminished by love, generosity, and mindfulness.*
- *Happiness is born of nonharming. Offer yourself and all beings dignity and respect, and happiness will follow.*
- *The mind and heart can be trained. Inner peace, compassion, and love can be awakened in every person: they are your birthright.*

The story of awakening told here is your story too. Each of us faces aging, loss, and death. We are confronted by the forces of fear, confusion, greed, and hate. And yet we are all also born with the capacity to discover inner freedom. Every child arrives in this world possessing fundamental nobility and basic goodness. Through practice, by cultivating a loving heart and a deep and respectful attention, we can awaken to these noble qualities in ourselves.

In these troubled times, the words and images of this book offer a profound message of hope.

Read this beautiful book slowly; savor it.
Reflect on its timeless message.
Let it quiet your mind and open your heart—to eternal wisdom and to vast compassion for your life and all of this world.

With blessings,

Jack Kornfield
Spirit Rock Center
Woodacre, California 2016

Introduction

Meditation has been one of the greatest adventures of my life. I discovered it purely by chance more than twenty-five years ago. A friend told me about it. He gave me an address. I rang a doorbell. Someone opened the door and began teaching me.

Right from the very beginning, it all made perfect sense to me and I finally felt at home. I've been hugely in love with it ever since. Indeed, meditation opens me up endlessly to a new world. It allows me to see things more clearly than I did before, to take care of the things I so far neglected and refuse to accept all injustice and deception. In other words, meditating allows me to live more intensely and more fully.

I've been teaching meditation from a secular perspective for fifteen years. To me, this feels like a more natural way to go straight to the purest heart of passing on the practice without mixing in religious, folkloric, or ritual elements. This was in fact the great lesson from my master, Chögyam Trungpa. He always presented the practice of meditation in a way that was more essential and deeper— and therefore more faithful to its tradition.

This commitment is under increasing threat in today's world. The main danger comes from turning meditation into an instrument of well-being or a tool to help you relax. Yet in reality the aim of meditation isn't to calm but rather to heal. It isn't there to lull you to sleep, but rather to enlighten you, which is a totally different thing. Wishing to calm yourself is to believe that by running away from the more difficult aspects of our experiences, all will be well. It's a naive wish, as any therapist worth their salt would tell you.

The second danger comes from introducing meditation as an instrument to make you more efficient. This angle is completely outrageous. Don't we suffer enough from the tyranny of efficiency and profitability? On the contrary, the point of meditation is to free us from this crushing oppression. I could very well imagine in the not-so-distant future an employee complaining about being crushed by a brutal and perverse hierarchy and receiving the response that he should "practice meditation for stress management." Meditation would then become a method of mind control in an updated vision of Big Brother, as portrayed by Orwell in his book *1984*.

Is this why I teach meditation? Is this its deep meaning? No, it isn't.

The goal of meditation is not to turn us into earthworms crawling around ever more blindly, but rather to turn us into beings that are more human, more capable of thinking, feeling, and loving better. In this sense, it represents a wonderful opportunity. In fact, meditation, in my opinion, is the final revolutionary force—and the only one that gets right down to the roots of our current suffering. It's

the only thing that cuts off the obsession with productivity and the dehumanization of a globalized management that sacrifices everything on the altar of economics. Why? Because to meditate is to remain in the present moment with attention and benevolence, to remove the desire to manage everything and to open yourself up to life and all that is possible. It's as simple as that.

BUDDHISM AND MEDITATION

Do we need to meditate to be Buddhist?

Just as there are people who practice meditation without having any links to Buddhism, there are also those who feel Buddhist, or at least feel strongly influenced by this approach to life, without meditating. There are three reasons to explain this attitude.

Some people are affected by the ideal of profound peace as manifested by the Buddha. In fact, isn't it interesting how there are so many representations of the Buddha in places that aren't specifically meant for spiritual practice? Many people are inspired by this example that connects with their desire to find a little peace in a chaotic and often violent world.

Others are mostly sensitive to the aspect of compassion and altruism at the heart of this tradition. The example of the Dalai Lama undoubtedly plays a strong role here. He doesn't ask those who come to listen to him or who read his works to convert and to practice Buddhism. His message asks us first and foremost to be compassionate and to strive toward the good of humanity. His remarks—that to be self-centered is negative, that true happiness lies in forgetting oneself, that by developing love and compassion we are doing something that is beneficial both to us and to others—are comprehensible to anyone. The depth of this message, and the manner in which the Dalai Lama presents it, immediately touches our hearts. What a relief in these times to hear such a down-to-earth person actually embodying his words!

Lastly, some find an approach to life in Buddhism that speaks to them. They appreciate its concern with promoting openness toward others, its tolerance, the importance of living in the here and now and the understanding of reality as being impermanent and relative. Its approach to suffering and how to be free of it may also be enlightening for some. Unlike a religious approach, this kind of Buddhism is much more like current therapeutic practices.

Do we need to be Buddhist to meditate?

There is no need to be Buddhist to meditate. Many people wish to discover the benefits of the practice without wanting to commit to rituals and refer to customs they are not used to. The reason this is possible today is because meditation has become entirely secularized. If someone wishing to meditate seriously finds deep enlightenment in the Buddhist tradition, he or she could also turn toward authors who think and shed light on meditation by studying it from the perspective of the neurosciences, philosophy, or social issues.

I personally teach meditation based on the great Western academic disciplines. I find that meditation has much to gain when challenged with the demands of Western rationality. This commitment doesn't mean in any way that we should turn away from what Buddhism teaches us. In fact, as Francisco Varela, the cognitive sciences scholar, says, it isn't because we have no inclination for Buddhism that we should neglect the study of the human mind this tradition has offered us over the centuries. It allows us to better understand the human mind.

Basically, what matters is not whether or not to be Buddhist, but rather to have a free and vibrant relationship with this tradition.

In this book, I won't be talking about the Buddha as a god, as the founder of a religion or as a master we should honor, but will simply be exploring the various aspects of the practice that we may encounter while meditating. So it's fascinating to note that when the emphasis of his incarnation has been on the feminine qualities of enlightenment, the Buddha has at times been portrayed as a woman. How better to show that the Buddha is first and foremost the face of a meditative state.

While I've written numerous practical books on meditation and how it can transform our lives, as well as producing several box sets on guided meditations, this time around I wanted to demonstrate the happiness that the practice can produce. Of course, as I've often written, meditating is not easy. Sitting down and entering into a relationship with our own state of mind can seem like an ordeal, making us feel so exposed or even shaken. But it's also the way for us to heal and be enlightened and free.

To demonstrate the depth of meditation, I've chosen to show you some of the most beautiful images of the Buddha.

It all began one day when, after seeing an ancient Buddha in a friend's living room, I felt a shock. As I looked at it, I was no longer seeing an image: I was seeing the very meaning of meditation. I understood there and then that every representation of the Buddha constituted a lesson. These representations of the Buddha didn't simply depict a person who once lived, but rather a symbolic state of the presence and benevolence that meditation allows us to discover. Even if you know nothing about Buddhism and meditation, a representation of the Buddha can be moving and give you a sense of openness and peace, of presence and goodness. In a sense, you're already getting an initial experience of meditation.

Every gesture and every posture of the Buddha in these images will show you a different aspect of meditation: anchoring yourself to the earth, not running away from your difficulties but overcoming them instead, celebrating the dignity of being human, becoming your own best friend, loving better, opening your heart, and taking care of the entire world.

It's important to note that, in all the various countries where it was established, Buddhism has managed to adapt itself. We can therefore speak of Japanese, Thai, Chinese, or Tibetan Buddhism. While this tradition has the universalizing aim of inviting everyone —whatever their social status or circumstances of their birth—to enter the Way, it has been careful to respect and celebrate the traditional lands it encountered. So the representation of the Buddha and the understanding of his teachings have taken on quite different accents, depending on the country.

By discovering Buddhist art you will experience everything from extraordinary mandalas of astonishing complexity, like Borobudur in Indonesia, to Tibetan thangkas of such stirring beauty. It's fascinating to notice how these very different forms can all remain true to the same doctrine.

Each painting and sculpture of the Buddha in this book will show you some aspect of yourself. Even the story of the Buddha I'm going to tell you is your story too. That person enclosed in a comfortable yet stifling cocoon, who has decided to go out and confront reality just as it is, that's each and every one of us! We, too, like the Buddha, are being invited to leave the comfortable palace of distractions in order to discover our own humanity. The Buddha I'm about to describe is therefore the Buddha within you—that is, the openness, the presence, the light, and the goodness that resides in the heart of every person.

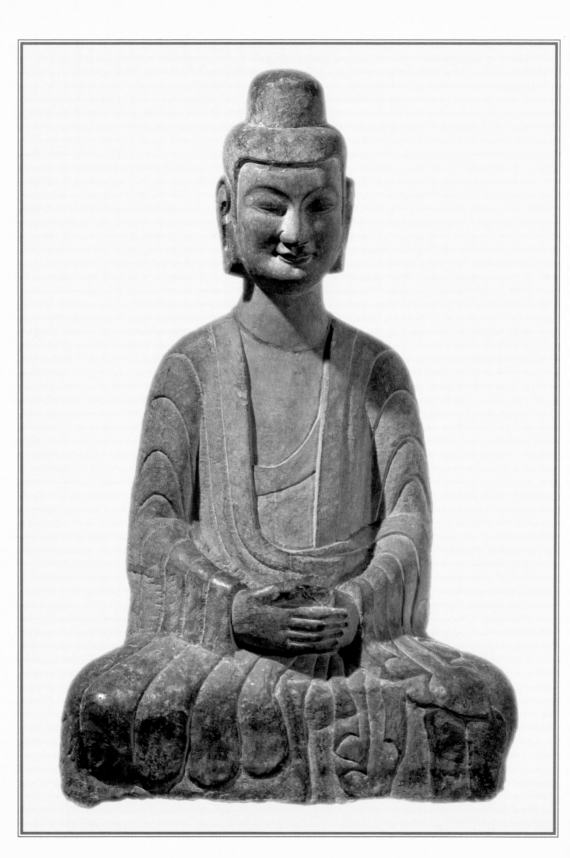

Introduction to meditation

Our existence is filled with joys and sorrows, with successes, failures, and numerous challenges. This is what gives life its richness but also makes it difficult. Meditation, in the way the Buddha taught it, allows us to better accept the diversity of our experiences by developing our full attention toward our body, our sensations, our spirit, and our heart.

By connecting us to our life experiences, it becomes possible to generate increased patience and benevolence.

How is this done in practice?

Begin by sitting down. In fact, how else can we be more fully attentive? It also happens to be what most representations of the Buddha demonstrate: he's always shown solidly anchored to the earth and doesn't leave the present in order to attain a particular state.

Once you're comfortably settled, be attentive and open to what you smell, see, hear, and feel. This attentiveness has the characteristic of being vast. It isn't about concentration. You can therefore be equally attentive to the situation as a whole.

To help you get there, focus on your breathing. Don't try to breathe in a particular way, just be present to the movement of the inhalation and the exhalation.

Three misconceptions

Although the main principles are often familiar, meditation still gives rise to many misconceptions, even among those who practice it.

The three main misconceptions consist in believing:
1. That meditating is to relax and attain a state of calm and well-being.
2. That meditating is to empty one's head.
3. That meditating consists of correctly applying a technique.

The first misconception is the most common one. Meditation is often presented as being a way to become calm and serene. This is quite wrong. Meditation isn't a form of relaxation. We're not trying to relax but rather to be more present.

It isn't about avoiding painful emotions or physical irritations, but instead connecting fully to these without magnifying them. At the time of the Buddha, people were already practicing different forms of meditation. Even if the Buddha didn't invent meditation, he was the first to demonstrate that the most helpful form would be in not trying to attain a state of calm but instead accepting to face

Statue in gray limestone, Gongxian caves, China, 6th century

our experience such as it is. When a person experiences suffering, he will not feel better by running away from his difficulties. He will feel better by connecting to them.

So, rather than trying not to be angry or sad, observe instead the nature of your emotions, their impact on your body, and the behaviors they trigger.

The second misconception: meditating requires you to empty your head. As we often tend to think of our problems over and over again, we hope that meditation will help us get rid of these. But to meditate is precisely to discover that our spirit is troubled. Recognizing this situation, rather than trying in vain to change it, is essential.

The goal of the practice isn't to become an ocean without waves but to recognize that the waves form an integral part of the ocean. In other words, the practice shows us that our thoughts are just thoughts. We do not therefore need to give them so much importance.

The third misconception consists in thinking of meditation as a technique that must be scrupulously followed. This is wrong. Of course, we need to respect certain elements in order to practice, but that isn't the essential part. The essential elements are presence, curiosity, and openness.

In southeast Asia, meditation is often called *vipassana*, a Pali word that means "seeing things as they really are." Meditating is, in fact, learning to see what is, as it is.

Some basic instructions

Simply begin by remaining seated wherever you are. You can close your eyes or keep them open. If open, direct your gaze downward, without focusing on anything in particular. Continue this way for a few minutes. If thoughts come and go, let them do so. Just be attentive to what's happening.

If you feel any discomfort, irritation, or tension in some part of your body, or any type of emotion, just notice and accept its presence. Don't do anything to reduce, eliminate, deny, or shift it. It's as simple as that.

Deepen the posture

It's important to be comfortably seated. Take your time to settle into your seated position. Your posture should be straight in order to allow energy to flow freely through your body. Also try to keep your heart open.

Sandstone, China, 9th century

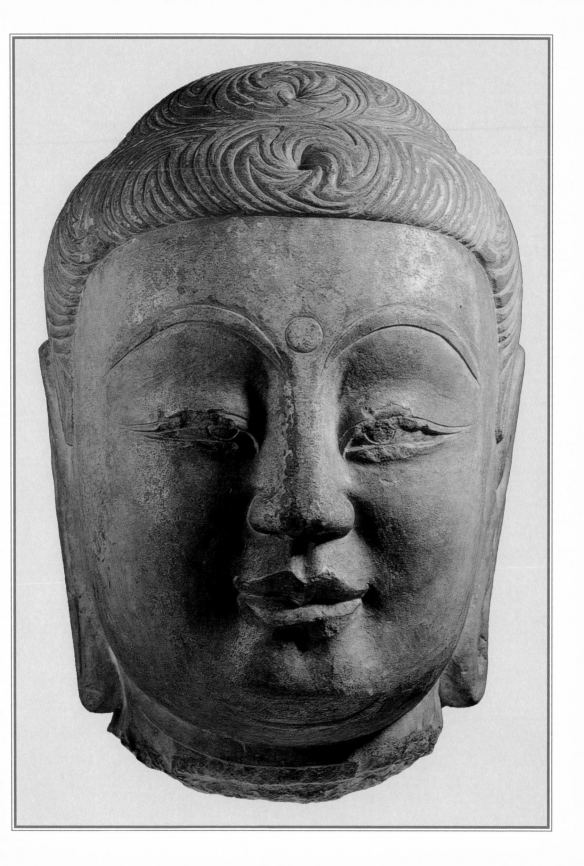

THE SIX POSTURE POINTS

1. *Be comfortably seated. It can be on the ground, on a cushion, or on a chair.*
2. *Your back should be upright but relaxed at the same time. We sometimes ask you to imagine a straight line starting from the top of your head going down to the cushion. If you feel that the line is leaning forward or is curved, straighten yourself.*
3. *Cross your legs comfortably in front of you. If you're sitting on a chair, your feet should touch the floor.*
4. *Rest your hands on your thighs in the position called the "resting mind."*
5. *Your eyes should preferably be kept open.*
6. *Your mouth should be slightly open so as to relax the face and the neck.*

Deepen the connection to your breath

The practice of meditation depends on discovering attentiveness. It's interesting to note that many texts attributed to the Buddha address this point. In one of his most renowned texts, the Buddha says, "A monk having gone to the forest, or to the foot of a tree, or to an isolated house, sits with his legs crossed, his back straight, his gaze directed in front of him. Attentively, he inhales; attentively, he exhales. Inhaling slowly he knows: Slowly I inhale. Exhaling slowly he knows: Slowly I exhale. Inhaling rapidly he knows: Rapidly I inhale. Exhaling rapidly he knows: Rapidly I exhale."

This is a beautiful description of the meaning of the practice.

As the breath is so precious, be fully attentive to its quality and to all that it's composed of. It's a good way to be more present and less lost in your thoughts.

Meditation on confidence

I've been teaching for about twenty years now, and I've noticed that one of the main obstacles I come across with Westerners is their lack of confidence. They constantly want to be sure they aren't making mistakes, which ends up hindering their practice.

When we look at how the Buddha practices, however, we see that he radiates confidence. When I focus on this point, people sometimes respond: "Yes, but he's the Buddha after all; he can be confident!" In other words, we think that in order to have confidence, we mustn't have any problems or weaknesses and be absolutely

competent. We may as well expect not to be human! In fact, it's the opposite: confidence is the prerequisite that we must first learn to cultivate. It's the only thing that allows us to connect to what is in a serene manner.

Begin by getting into the posture. Sit yourself down on your cushion like a rider getting on his horse. Don't apologize for being there, just be fully there.

Then let yourself feel that, simply by breathing, you're maintaining all of your vital functions and that you're therefore already saying yes to life.

PART I

Initiation into meditation through the life of the Buddha

"Meditation is not supposed to create relaxation nor indeed any other pleasant condition. You simply sit down and let things rise through you—tension, passion, aggression—all sorts of things will arise. Buddhist meditation therefore is not like the mental exercise required to put you in a state of relaxation."

CHÖGYAM TRUNGPA

Rereading the life of the Buddha lets us discover the path he proposed to humankind as well as the practices he formulated. It's therefore not so much the biography of a specific man, but rather a description of the path's direction that we could adopt.

The events characterizing his life—whether it be his birth, his golden childhood, his renunciations of the world of dreams and of pleasure, his doubts, or his commitments—are all various ways to describe the trials that those wishing to open their hearts must go through.

In my view there are two qualities in the Buddha's life for us to consider. On the one hand, it shows us a path we could take. Thanks to his story, we are better equipped to understand the trials and adventures we come across. On the other hand, it explains the ultimate aim of the path: to be like the Buddha, a human being who was fully human. The Buddha is indeed, first and foremost, a human being who made peace with his own humanity and never tried to be a god.

As Jack Kornfield, one of the most important Buddhist teachers in the West, says: "Meditation practice doesn't require us to become

Buddhists, disciplined meditators or indeed spiritual beings. It simply invites us to discover the capacity to be enlightened that we each possess as humans." The Buddha isn't leading us toward a kind of ethereal perfection, but rather to become who we are. His life describes this voyage toward our own being, a voyage made with attentiveness, benevolence, and compassion.

The episodes of the Buddha's life are often represented in a somewhat unrealistic way. We know, in fact, that the Buddha wasn't born in a magnificent kingdom. He wasn't the son of a great monarch and never lived in opulence and idleness. As the child of a modest countryman belonging to the Gautama family, he would probably have experienced a harsh youth, exposed to many dangers. Historians are still working on establishing the truth. But then why have such representations? In fact, the artists were trying to show a spiritual meaning that could affect each one of us.

This is what I will now show you.

Queen Maya's dream and the luminous aspect of the mind

One full moon night during the rainy season, Maya, the wife of the king, had a strange dream which shook her to the point where she had to tell her husband about it: "A silvery white elephant came down from the mountains, entered my chamber and knelt down in front of me; in his trunk, he was carrying a lotus. The voice of a bird woke me up. What a lovely way to be disturbed! Just telling you this fills my soul with emotion." She added that she sensed she would soon become a mother.

In the image, the queen is in the center, lying on a bed with four legs. A ewer and an illuminated lamp complete the furnishings. Maidservants watch over their sleeping mistress. Above her is the divine elephant. (In India, the elephant is the symbol of perfect wisdom and royal power.)

This image of the white elephant illustrates the fact that the human mind, by its nature, is luminous. Does it not light up our sensations, our emotions, our thoughts and reality all at the same time? A ray of light can be directed both toward a jewel and toward a piece of waste without it being changed by what it lights up. The practice of Buddhism aims to help us find the initial clarity of our own mind, which has been obscured by fear, ignorance, and all our confused emotions and attachments.

In other words, the focus of the various practices and meditations is to find our wise and benevolent mind. And even if we sometimes experience great turmoil and encounter enormous difficulties, we mustn't get discouraged or blame ourselves for them. Our difficulties aren't the end of the story; they make up only a part of it. As Jack Kornfield says: "They are part of your journey toward great love and great understanding, a part of the dance of humanity."

> *Space is without color and form;*
> *Unchanging, it is neither dark nor light.*
> *In the same way, the luminous mind had neither color nor form;*
> *It is not clear, nor bad nor good.*
>
> TILOPA

This verse by the Indian master Tilopa aims to show us that, deep within us, we're perfect just as we are. We're all born from the trunk of a white elephant. We certainly have to work to calm our minds, have confidence in our own dignity, and open up our hearts, but what a difference it makes to our perspective knowing that this seed of goodness already exists and that it asks only to be allowed to blossom!

Bharhut, India, 2nd century B.C.E.

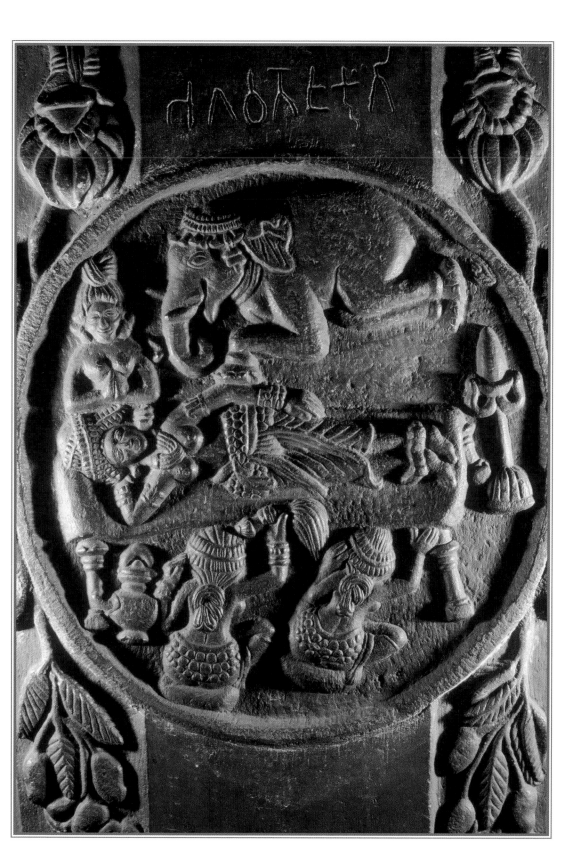

Don't let yourself be imprisoned in a palace of distractions

The Buddha's father summoned the sixty-four great Brahmin sages, who were keen astrologers with the ability to interpret dreams. Each one predicted that the queen would give birth to a child bearing the thirty-two marks of a great man. He would either be a *cakravartin,* meaning a monarch, or a great spiritual master.

The king was frightened by the idea that his son could renounce his succession to the throne for a spiritual path. He decided to try everything in his power to prevent him from doing this. He built a huge palace to shut him away and provided him with all possible pleasures. The future Buddha received the best conceivable education and was granted every desire. He was offered the most beautiful women, the best delicacies, and the most excellent entertainment. His father tried to shield him from any painful sight capable of producing a sentiment of renunciation in him.

Our society can sometimes be like the Buddha's father. It creates a palace of pleasures, distancing us from reality. We may therefore think of sickness as an accident, old age as a flaw, and death as a catastrophe, and spend all our time trying to forget this sad reality.

Living like this, constantly searching for a succession of pleasures, can never fulfill us.

Meditation: Make an appointment with yourself

When was the last time you sat down without moving, being distracted, or being disturbed? Without the television or the radio, a book or a magazine. Without needing to think or solve a problem. Without preoccupations. Simply being present to what is within you.

Meditation is about taking this kind of break. Leave the palace of your activities and come back to what is essential.

As you remain seated in meditation, just be attentive to what you feel, without any expectations. Simply doing this is already a wonderful thing.

Great Stupa of Amaravati, India, 2nd century

Creating the Buddha within ourselves

As she sensed the birth approaching, Maya left the royal palace to go and give birth at the home of her family, as was the custom. During this beautiful month of May, the full moon and the Lumbini Garden were both radiant with beauty. After taking a few steps, the queen noticed a tree whose branches were bowing down, as if they were trying to reach out to her. The queen seized one of these branches and, remaining still for a moment, gave birth painlessly to the child.

Although out of season, the tree was covered in flowers to celebrate the child's birth. Instantly, as the legend goes, all passion, hatred, confusion, pride, sadness, fear, jealousy, and selfishness disappeared. Bad deeds ceased. Sicknesses were healed. The hunger and thirst of the hungry and thirsty were appeased. The insane recovered their minds.

The child was named Siddhartha. They added Gautama, the name of the clan to which his family belonged. This is why we call the Buddha either Siddhartha or Gautama.

Meditation: How do we create the Buddha within ourselves?
According to Dogen, the founder of Zen in Japan, there's a simple way to become a Buddha: "Abstain from any action which does not do good, do not be attached to birth or death, be benevolent toward all living beings, respectful of elders and affectionate toward the young, without rejecting nor desiring anything, without developing thoughts or preoccupations, and you will be called a buddha. Look for nothing else."

You can create the Buddha within yourself at any moment of your life. This is like being the mother of the Buddha.

Bronze, Nepal, 18th century

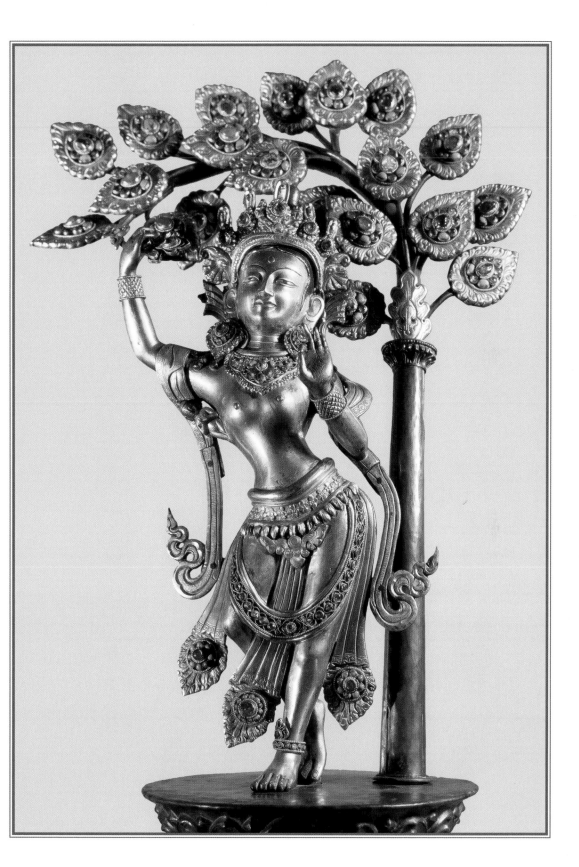

True happiness

The Buddha grew up receiving an education in keeping with his position. For his sixteenth birthday, his father had three palaces built—one for the cold season, one for the hot season, and one for the rainy season—and decided to choose a wife for him from among the daughters of the neighboring monarchs.

The prince was asked what he wished for. He gave no value to the caste of his future wife, but wished for her to be firm in the face of truth, modest, and to always act with kindness. A young woman, Yashodara, perfectly met with these conditions, but her father refused to give his daughter to a man who could not prove he was truly skilled in the arts, or knowledgeable on the rules of fencing, archery, scripture, or good with numbers.

A great contest was organized. The prince demonstrated his skills in the twelve arts. The young Yashodara was then given to him to be his wife.

The texts describe the numerous pleasures to which he could then devote himself. However, in the midst of these various pleasures, he realized this was not the life he wished to lead. None of this managed to satisfy him.

His privileged situation allowed him to understand early on what most men take far longer to discover: that having a high social standing, being rich, intelligent, and possessing everything you want is not enough to acquire true happiness.

Meditation on true happiness

We expend a great deal of effort to improve the external conditions of our existence, but we neglect our own mind. Yet it's precisely our state of mind that allows us to be happy. There are examples to prove this: some, who lead a comfortable life, are unhappy, while others, who have almost nothing and encounter difficulties, radiate with joy.

You, too, can feel the joy of being in the here and now, wherever you are. There's no need to wait for the arrival of a particular event or person. You can experience this feeling right now. Here are some instructions to help you get there.

Settle yourself down on a cushion or on a chair. Take the time to notice how pleasant it feels to be sitting. Then sit up straight. It's such a good feeling to no longer need an excuse to be, and to feel yourself sitting upright. Then feel how good it is to breathe. and simply be present to the joy of inhaling and exhaling.

You are now feeling the ordinary yet magnificent simplicity of just being.

This state isn't perfect, of course. It doesn't prevent fatigue, tension, or occasional painful emotions from overwhelming us. But these discomforts don't ruin our happiness of being.

It's this happiness, independent of external circumstances, which the Buddha teaches us.

Painting on hemp, Korea, 18th century

Sickness, old age, and death

One day, the prince decided to venture out of the palace. His father, terrified at the thought of his son committing to a spiritual life, attempted to transform the whole town into a palace. His people chased away the poor, the old, the sick, and all those who were too unsightly. By doing this, they were trying to create a perfect world.

But on this day, despite his father's decision to decorate the town in such a way that nothing could bring sorrow to his eyes, Siddhartha saw a man who was not happy like the others were. His coachman explained why:

"This man, my lord, is suffering from old age, his organs are weak, he lacks strength and energy, he's incapable of action, and finds himself relegated to the forest like a piece of wood."

Shaken by this, Siddhartha then asked:

"Is this condition specific to his family or is it common to all humanity?"

"My lord, this is not a case specific to his family or to the kingdom; for all people, old age follows youth. Your parents, all your friends, and everyone will end up like this. There is no other way for living beings."

On a second outing, the prince came across a sick man, and on the third, he saw a dead body. He then understood that no one could escape old age, sickness, and death.

It doesn't matter whether the story is real or symbolic, as its meaning is powerful nonetheless. Today, more than ever, our society considers sickness as failure and old age as degeneration—we even build retirement homes to isolate those who are "afflicted" by these. As for death, it's hidden away and even denied. The Buddha is one who dares to face reality, with all its abrupt and sometimes painful characteristics.

Meditation on the essential

Where are we in our lives? What have our priorities been until now, and what do we wish to accomplish in the time that remains for us to live?

We're often submerged in painful thoughts, consumed by anger, speaking words that we then regret. Convinced we can do nothing about this, we lose ourselves in pointless activities and forget just how precious our existence is.

Why limit our lives with such narrow and petty goals that leave us with a bitter taste? Why not turn instead toward what's essential, the pure joy of being, unconditional love, and true presence? Just because we can't measure these qualities doesn't mean that we should ignore them.

Mural painting from Buddhist temple, Chiang Mai, Thailand

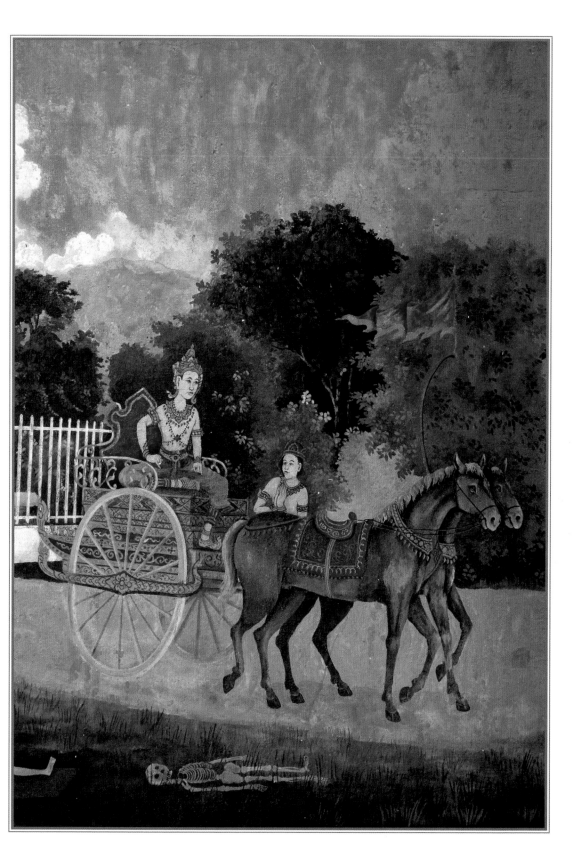

The joy of setting out on the journey

In light of this experience, Siddhartha was determined to end the masquerade of a princely life which couldn't satisfy him. People make the mistake of wishing to live in the cocoon of their fragile palaces made of gold or silver. Such an attitude does not give them true joy, as do moments of internal peace, love and goodness, openness toward others and to the world, and the experience of beauty.

Contrary to what has sometimes been written about it, Buddhism doesn't take a pessimistic approach. It recognizes, with courage and honesty, that wishing to escape the intensity of life is not really living at all. It actually distances us from what we truly are.

Siddhartha left the town in order to think, and came across a wandering monk dressed in a long saffron-yellow robe, whose face was radiant. This monk explained that he lived in the forest and was searching for peace in his heart.

Siddhartha decided to do the same. He left his palace, renounced his life of luxury, his son, and his wife, and advised his father of his intention. His father, not wanting to let his son leave, reinforced the guard around the town to prevent him from carrying out his plan. But Siddhartha managed to escape in the middle of the night. He saddled his horse, which the gods, according to legend, carried to prevent the noise of the hooves from waking the guards.

When he arrived at his destination, he sent back his steed. Siddhartha was twenty-nine years old. A new life was opening up to him. He was no longer imprisoned in the static immobility of a conventional life.

Meditation on the meaning of the path

Life is a path. What an amazing perspective! Instead of rejoicing over good news and lamenting over the bad, we can change our behavior. From now on, we can be ready to work with anything that happens. At the same time, instead of believing that our well-being and our happiness depend on circumstances, we understand that they actually come from our state of mind. All this goes completely against what we're used to.

Shantideva offers an image to help us understand how we react when faced with difficulties: when we suffer while walking on the earth, from the heat, the cold, discomfort, or various wounds, we would love to be able to cover the earth with leather. Isn't this in fact what we try to do when we hope to end our suffering by focusing on external circumstances? But where could we find such a large quantity of leather? How do we accomplish such a project? What could we do to prevent any difficulty from ever troubling us? What if we accepted, instead, to cover our feet with a little leather? It would be as if the whole world was covered with it.

This is what the Buddha proposes. He invites us to work on our own mind.

Imagine that you catch a cold and feel unwell. You could let yourself get upset ▶

Wat Ratcha Sitaram, Thonburi, Thailand, 19th century

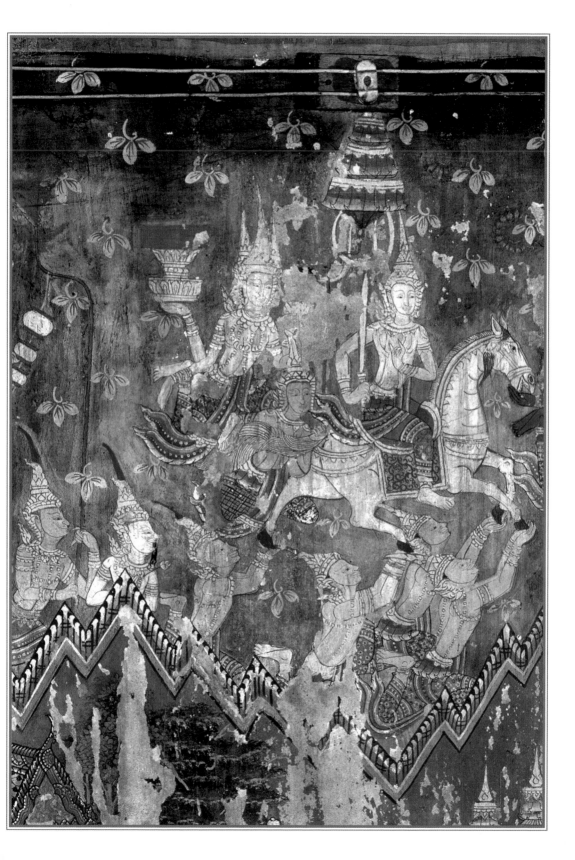

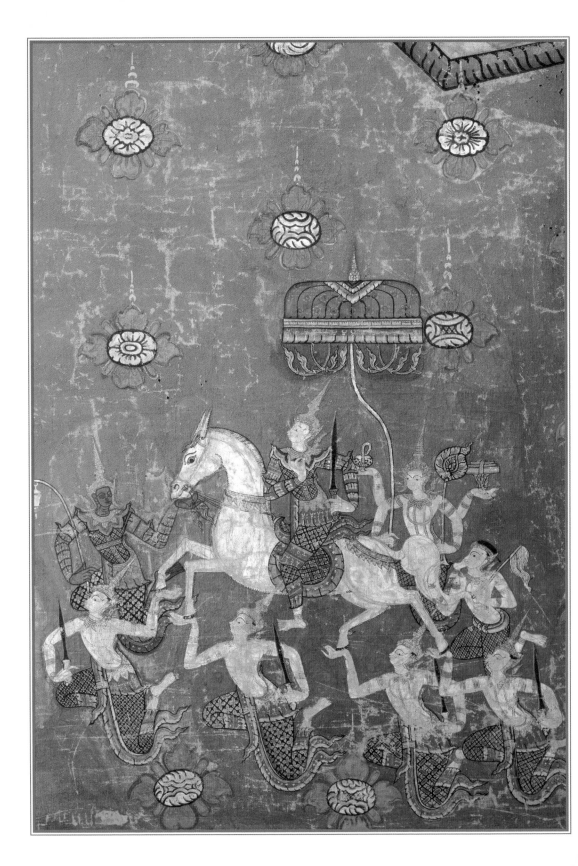

by your fate, bemoaning the need to stay in bed, or you could decide to live in the moment. Naturally, this isn't very pleasant, but it also gives you the opportunity to rest while waiting for your health to recover.

In other words, when something torments you, when you encounter difficulties, when someone tries to harm you or you feel pain, you need to work with your own mind.

You are then on the path. What matters is not your destination but the journey. What wonderful news! If, at some point, you become discouraged or lose ground, don't worry. It isn't serious. You don't have to be perfect, or be successful at a task, but instead work moment by moment with what arises.

ABOVE: *Stupa, Sanchi, India, 2nd century* B.C.E.
LEFT: *Silk painting, Thailand, 17th–18th century*

What should we give up to be truly happy?

The Buddha started walking and noticed a man wearing clothes made of coarse ocher cloth. He offered to exchange his own clothes made of precious fabric with him. Then he decided to cut off his hair and shave his head.

In India, as in many traditional societies, long hair is a sign of virility indicating a person's aristocratic quality. By giving it up, the Buddha was giving up the advantages of his birth. In other words, he recognized that the values promoted by society have a relative meaning. Only the commitment to work on your own experience and to contemplate your own mind directly is truly satisfying. It's this, and only this, which entitles a person to true nobility.

Thanks to this event, we clearly understand that the goal of entering into the Way is not to find security and happiness by protecting us from everything. This common vision of spirituality is deeply flawed. The Buddha abandoned a life of pleasures to enter into a life centered on austerity and a certain form of non-attachment. From then on, he was at the service of all humanity.

When taking refuge, which is the sign of entering into the Way of the Buddha, it's still customary today for the master to symbolically cut off a lock of hair from each apprentice.

Meditation on the joy of renunciation
The teachings do not ask us to deprive ourselves of what is beneficial to us, but only what brings about our suffering and misguides us.

What about you—what would you have to give up? What attachments prevent you from being free?

Reflecting on such a question is to discover that our attachments and our fears form a shell that gives the illusion of protecting us. In reality, it imprisons us.

▶

Wat Ratcha Sitaram, Thonburi, Thailand, 19th century

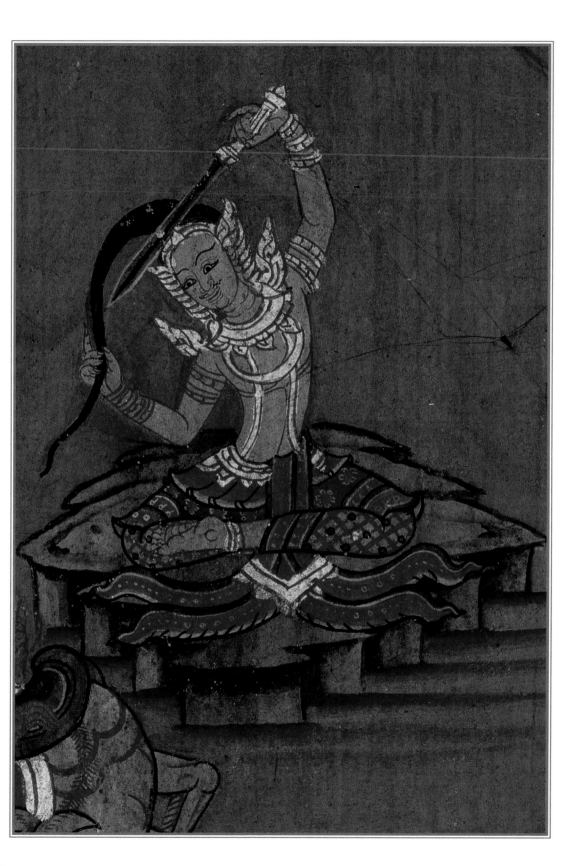

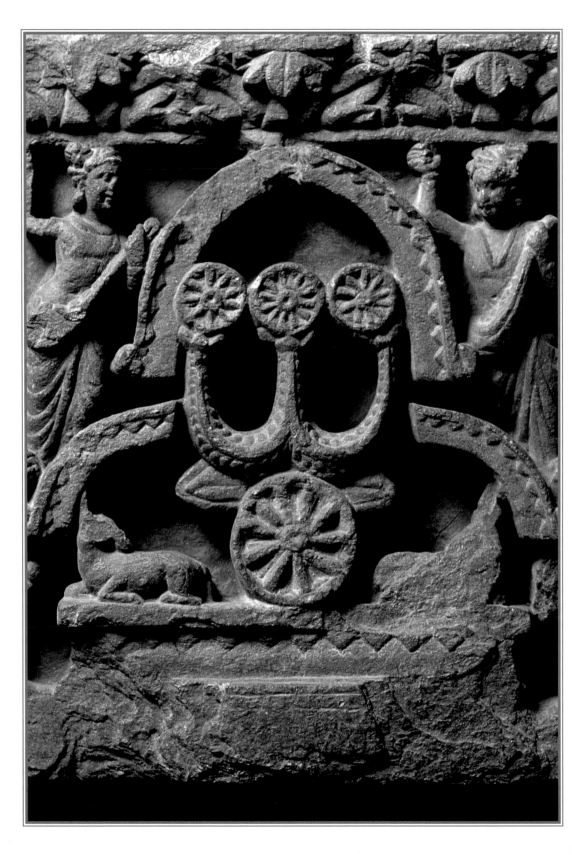

THE MEANING OF TAKING REFUGE

What we call "taking refuge" consists of fully entering the Way. It's a commitment with one's entire being to walk in the footsteps of the Buddha, an example of openness, to listen to the dharma and its teachings, and to lean on the community of all those who practice Buddhism.

It's a vey powerful act, and more so because it makes us get out of our usual habits. In fact, we take refuge every day, whether in pleasure, in social success, in power, or in a political party … The Buddhist Way invites us to take refuge in openness and in accepting that to do this we must transcend all rigid identities.

In reality, there's no path that is already plotted, or a highway to guide our lives. Nobody is in this sense "Buddhist"—a recent term, which didn't exist in the ancient texts. It's simply possible, following the Buddha, to cultivate presence, gentleness, and clarity.

Committing to this path is not an act that we can carry out once and for all, like a "conversion" or a baptism, but an act that must be renewed each day.

◆

ABOVE: *The three jewels (Dharma, Sangha, Buddha), Songgwangsa temple, South Korea*
LEFT: *The three jewels, India*

Neither too tense nor too relaxed: searching for just the right attitude

The Buddha tried various approaches for seven years: holding his breath, standing on his head, sitting on fire, not eating, and avoiding sleep … His ascetic efforts were, in a sense, futile. The Buddha was simply intoxicated with his own power without finding any peace. The desire to control your mind and subjugate your body to your will is not the Way.

The attempt to purify yourself has no limits. It can make spiritual practice very idealistic. It commits the person to wage war on his body, which can only end in death.

The Buddha realized that making himself suffer would lead him nowhere. This became a very important moment of enlightenment for him.

He therefore abandoned the strict fast he had been practicing until then, and agreed to eat a little rice. His followers were disappointed, and left him saying: "The ascetic Gautama is senseless and stupid—he has lost the Way."

He remembered that long ago, as a child sitting at the foot of a tree, everything seemed joyous and simple. He had enjoyed moments of profound peace, where he felt free of the weight of conflicting emotions, of his usual thoughts, and of all cravings. This ordinary state, that each of us has also known, is what we should try to cultivate from now on—not just by waiting for it to occur by chance, but also by finding the path that lets us live in this open presence.

Meditation: Neither too tense nor too relaxed

Meditating consists of opening ourselves up to all that happens to us and remaining calm. It's as simple as that.

Of course, this requires some effort. But this effort isn't the proactive kind we're used to. It consists of paying attention, moment by moment, to what is. Since we can't fight our thoughts and emotions, we need to understand that paying attention to these with honesty and humor is far more helpful than making the excessive effort required to avoid them.

Meditation invites us to cultivate an attitude that is neither too tense nor too relaxed. For many of us, it teaches us this just-right attitude that will gradually reign over each moment of our lives.

Naturally, this is far from simple. This is why meditation requires some perseverance. Devoting twenty minutes to its practice daily is a good average. It's better to practice little and often than for a long time but only occasionally. As Matthieu Ricard points out: "For a plant to grow well, you need to water it a little bit every day. If you just pour a bucket of water on it once a month, it will probably die between waterings."

Manjushri Monastery, Chengdu, China, rebuilt in the 17th century

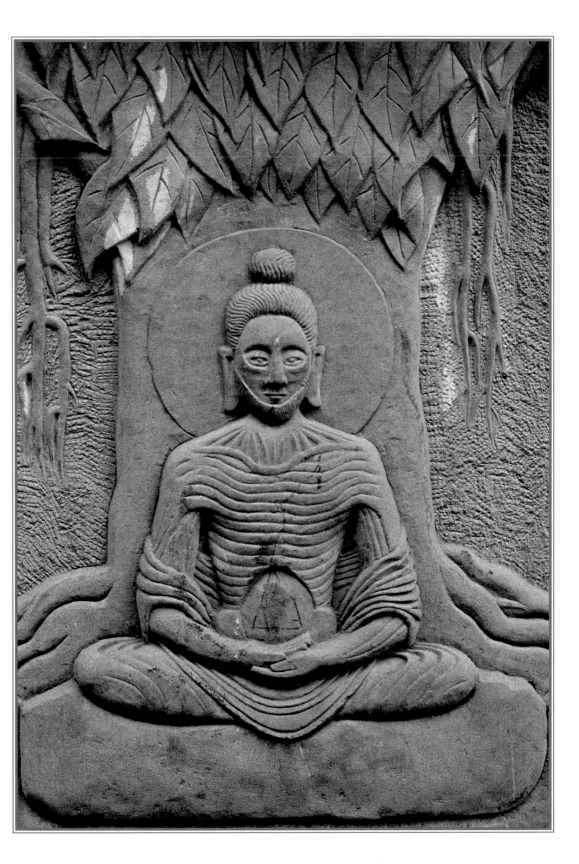

The posture for meditation

The Buddha went to the riverside to bathe. Close by, he saw a man cutting grass and asked him if he could give him enough to make a seat. The man willingly gave this to him.

The Buddha saw a fig tree and walked seven times around it before sitting at its foot. He sat with his body held straight and his mind alert. He had decided that from now on he would discover things for himself and not depend on some established model.

It's by learning to be fully present in this manner that the Buddha found the Way.

It is interesting to note that he sat next to a tree. In fact, the practice of meditation teaches us to become like a tree. Like the tree, we learn to root ourselves in the ground and lift our bodies toward the sky—simply being there, without any issues or preoccupations, simply being open.

> He who at first neglects, then ceases to be, spreads in this world
> a radiance similar to the moon free of clouds.
>
> BUDDHA

Meditation on posture

We should begin with the clear understanding that the practice of meditation is, first and foremost, a physical exercise. We sometimes get it wrong by turning it into an intellectual exercise, for example, or a kind of exercise of being without thinking.

▶

FULL AWARENESS OR FULL PRESENCE?

In Sanskrit, and in most Asian languages, the practice of meditation is referred to as bhavana, *which could be translated as "being a certain way"—like nature, which simply is, without reason or justification. From this perspective, meditation is simply to be, allowing what there is to arrive in its fullness, toward its complete expansion.*

In English, we often talk of mindfulness. This is indeed a very fortunate term. It clearly indicates that our "mind" should be full, entirely where it is—allowing reality to fully be.

We must clearly distinguish this notion of mindfulness from that of consciousness. In the West, consciousness is reflective and dualistic, implying a return to oneself, which is a contradiction of the experience of direct and natural "full presence." In mindfulness, we are with what is, without trying to grasp it, simply assuring ourselves of its presence.

◆

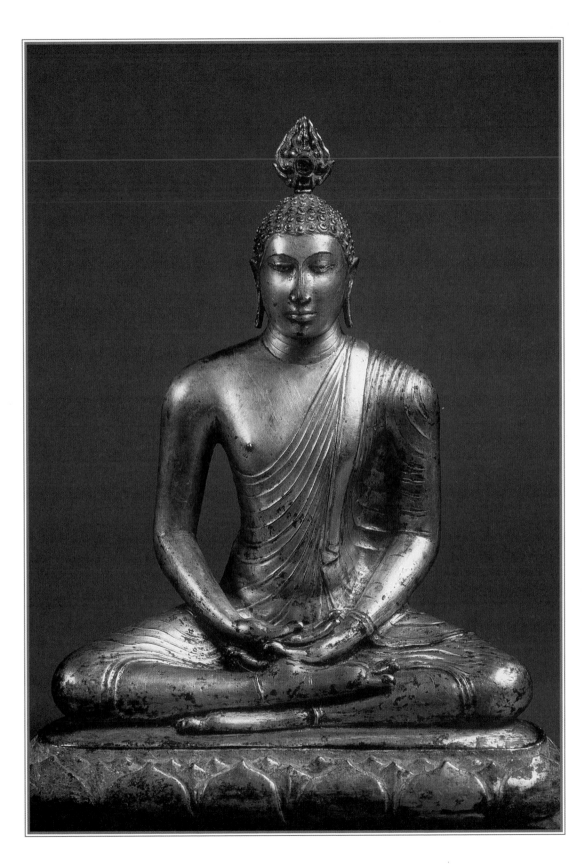

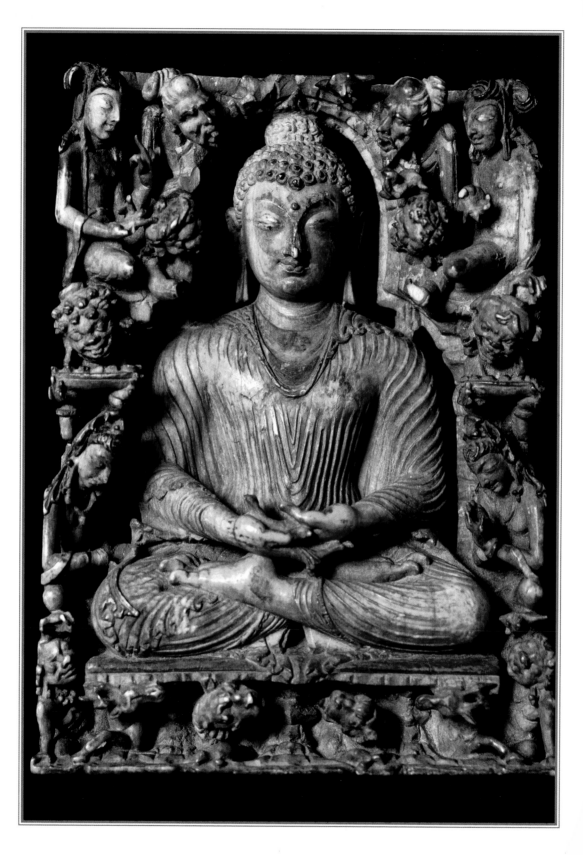

The designation of "full awareness" given to meditation contributes to this confusion. Yet meditating is to feel presence with your body, with all of your body. Such a phrase is unfortunately not that clear, because it implies the understanding that our body is not separate from our mind or our emotions. It's impossible to be connected to one without also being connected to the other.

Entering into a relationship with your body has two aspects

First of all, we must be fully present to our being. Trust our sensory perceptions. Smell what we smell. Listen to what we hear without interpreting anything. Simply remain in the perception: the sound of water flowing, cars passing by, someone coughing …

We connect with our body by holding ourselves in a particular way. The Zen master Deshimaru used to say that posture keeps us from imposture. In fact, the posture implies a certain conduct of our profound being. Try it, and you'll see that adopting this posture—the posture of the Buddha—will change your state of mind.

Many neuroscientists today are working on the phenomenon, and are discovering that adopting a physical attitude can transform our emotions. When tests were carried out on people, the way they responded was completely different depending on whether they were in a confident or submissive position.

The important thing is to understand that the anchoring within our body is essential for creating stable and open attention.

Kashmir, 8th century

How to work with our difficulties

Mara, the great demon, tried to prevent the Buddha from attaining Enlightenment by causing all sorts of disruption.

I think there's a great lesson here. When we practice, the merest obstacle can discourage us. It helps to know that the Buddha, on the eve of his Enlightenment, also met with great difficulties.

First of all, there were the daughters of Mara, who congratulated him and danced around him, supposedly to honor him. The Buddha remained still. They then tried to persuade him to rest a little and to cease his efforts. The Buddha didn't move. These seductresses symbolize the belief that we think we're accomplishing something important. Believing that we're doing something extraordinary because we're committed to a spiritual path is a manifestation of pride. In reality, we should never stop pursuing our efforts to purify our heart and better love the world.

Mara then sent his soldiers to attack him. They represent the fears we may feel. The Buddha wasn't in the least troubled by this and calmly continued his practice.

The Buddha faced many and considerable threats matching the height of the openness he was experiencing. It's very important to emphasize this, so as to avoid turning Buddhism into empty mysticism. The Buddha is not a god who was protected from the world's suffering. He saw the dishonesties of life, both at the material and spiritual levels. He was tested with confusion, chaos, and violence. He looked at these situations clearly and rigorously, and this is precisely what constitutes his greatness.

It bears repeating that the spiritual path is not a pleasure trip: it leads us to confront reality, our own mind, and the disorientation in which we live in a very direct way.

I believe this is where we find the meaning of the meditation path: seeing ourselves as we are. Of course, we're bound to discover aspects of ourselves that we would rather not know: our arrogance, our weaknesses, our need to be continually reassured, and our anxieties … But, if we want to weaken their power over us, we have to face them.

Another lesson we can take from this is that these aspects are not faults or sins, but temporary mental habits that we can work on.

Meditation on the difficulties of life

It's important to be aware of the unique value of the meditation practice taught by the Buddha. By putting us in touch with our fears, our anxieties, our anger, and our sadness, it confronts us with the limitation of our life. From this point of view, the practice is more of a test of the truth than an experience of calm.

I realize that this is a little disconcerting. We would no doubt prefer meditation to be something that can comfort us, make everything go well and give us everything we desire. But it's precisely because it makes us confront our difficulties that meditation is precious. It saves us from two of our usual pitfalls: the desire to run ▶

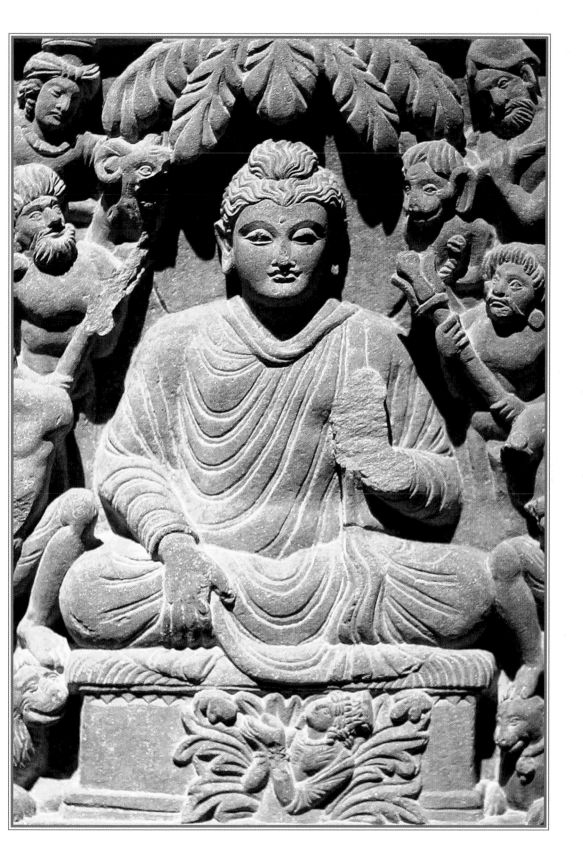

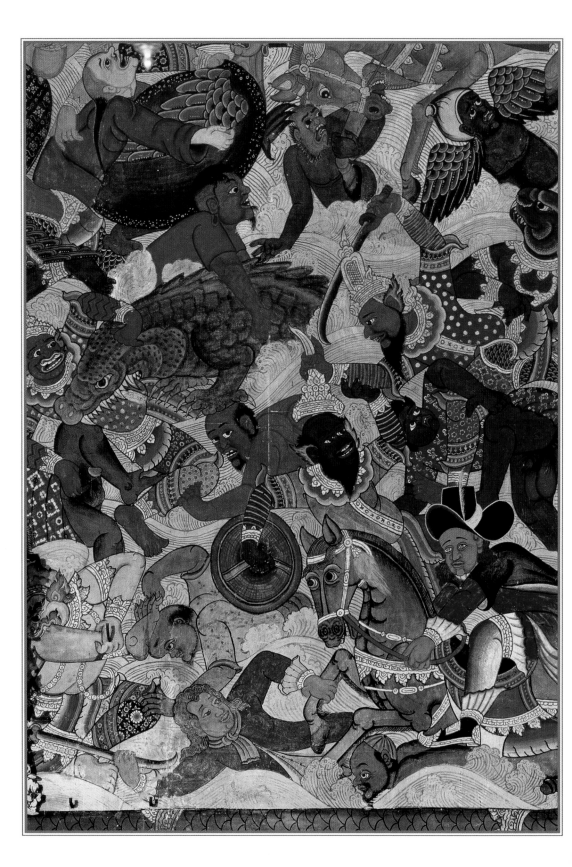

away from what we feel or trying to control this—two attitudes that only make us even more unhappy.

The first habit is where we try to run away from our anxiety or from uncertainty. We act as if nothing is wrong and blame it on circumstances. Meditation, however, invites us to gently confront our difficulties and take charge of our life just as it is at that precise instant.

The second habit is where we try to take control. We often talk these days of "managing emotions." This term is revealing. We should only be managing our bank account, never our emotions! The use of this word indicates more of an obsession with control than openness. The Buddha doesn't manage his emotions; he doesn't try to obstruct them, nor destroy or favor them. Readily meeting them as they are, with a welcoming attitude, he allows them to come to him, and then to dissolve.

This is key to the practice: feel what is present in our experience, then stop referring back to it and let it go.

Sorrow, loss, and suffering only get worse when we try to ignore, deny, or attempt to control them. The path to healing begins with facing our difficulties. What we took to be monsters then appear a lot less terrifying, and we find ourselves humbler and more confident than we thought.

> *When you suffer, you must suffer. When you feel good, you must feel good.*
> *Sometimes, you must be a buddha who suffers. Sometimes, you must be*
> *a buddha who cries. And sometimes, you must be a happy buddha.*
>
> SHUNRYU SUZUKI

Wat Suwannaram, Thonburi, Thailand, 19th century

Overcoming confusion

Mara's army was composed of terrible monsters with lolling tongues, prominent fangs, smoldering eyes, deformed bodies, some without arms, some with a thousand arms and with ferocious animal heads, not unlike the gargoyles of our Gothic cathedrals. They represent the mind's confused tendencies or a person's unbalanced state, which diverts them from the path to freedom. These monsters symbolize our own fears, our anger, our blind ambition, and our hatred.

Instead of describing this confusion in psychological terms, as we tend to do, the Buddhist tradition describes it in terms of demons attacking us. According to this, I'm wrong when I say: "I am angry." In actual fact, it's the demon of anger arriving, and my task is not to succumb to it. And, indeed, don't we sometimes have the impression of suffering an *attack* of anger or jealousy?

Meditation, which teaches us to look at confusion without reacting, is very helpful. It transforms fear and pain. The legend also tells us that the arrows shot by the army of demons toward the Buddha changed into flowers when they came into contact with him. What better way to demonstrate the meditative experience?

Making friends with ourselves

The Buddha's attitude—that of maintaining his gentleness as he faces Mara's army—is enlightening.

Meditation practice is not a harsh discipline. It should be experienced as a gesture of kindness toward ourselves, life, and the world. Of course, we're imperfect, sometimes confused; sometimes we make mistakes and many things hurt us. Instead of blaming ourselves, we should think of these things as good reasons to practice. In fact, if everything were perfect, why would we bother beginning the journey?

We don't always realize it, but practicing in order to improve ourselves is a subtle form of aggression: the idea that what we are doesn't quite work, that we need to change. Benevolence commits us to begin opening ourselves up fully to what we are with genuine tenderness. As Pema Chödrön writes: "The goal of meditation practice is not to reject ourselves and become better. Its aim is to make us friends with the person we already are." This realization provides a deep sense of relief.

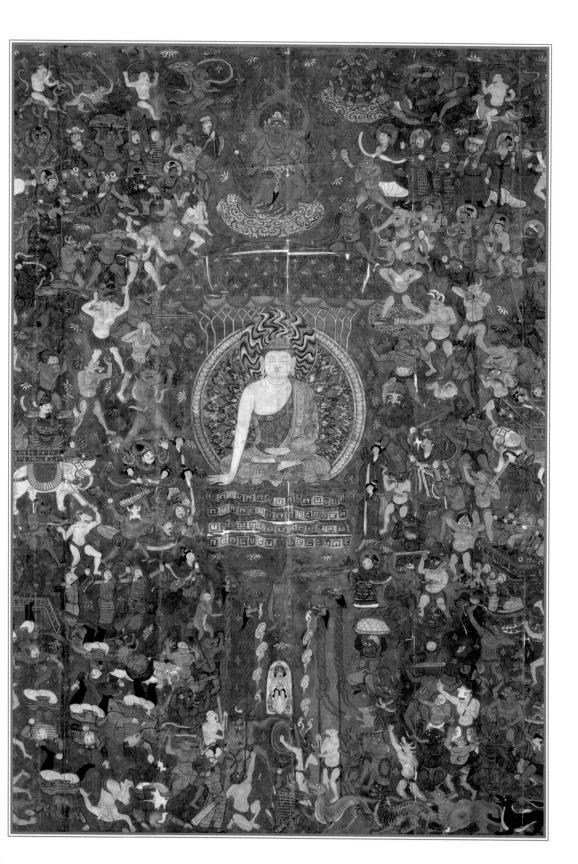

On earth, open to the sky

The Buddha was then challenged by Mara himself, who questioned his Enlighten-ment. "How can you prove to us that you are not an imposter?" he asked. The Buddha didn't point to the sky nor invoke any god, but instead touched the earth, saying: "This is my witness." On hearing these words, Mara was vanquished and disappeared.

What matters is simple reality. It's the only thing that can bear witness to our understanding. This is where the profound meaning of the Buddhist tradition lies. Not in invoking a god or some transcendent place, but in understanding that the truth lies in the here and now. Instead of looking for external help, the Buddha began to work on himself. It is up to those who practice meditation to do the same.

Notice in the image that, while one of the Buddha's hands touches the earth, the other holds a bowl, symbolizing his acceptance of what can arise.

This dual gesture—touching the earth, holding the bowl open to the sky—symbolizes the path the Buddha offers to mankind. He invites us to adopt an attitude that is dynamic toward the world and receptive toward the sky. The ignorant person acts in the opposite way, passively accepting the world and resisting openness.

This is important. We sometimes accuse those who meditate as being closed in on themselves. In reality, their practice aims to let them be as open as possible to what is, and, in this way, to be a valuable aid to the world.

Meditation on how to place yourself in the present

When you meditate, begin by connecting to the earth with your whole body. To do this, search for a stable and comfortable posture. It doesn't matter whether you choose to sit on a chair, a cushion, or a small bench. The important thing is to feel the contact with the floor and to feel truly calm. Doesn't this already give you a sense of relief? Furthermore, you may have already noticed that when you're anxious or stressed, you tend to lose your stability. Your mind is in a panic—everything seems out of control. It's a little bit like being perched above yourself.

Wanting to prove that you're right, that what you've achieved is important, will only end up getting in the way. Be like the Buddha and rely on reality. This will give you strength and determination.

Suppose your child is suffering from an incurable illness. You don't know what to do; you can't remain lying in your bed, which ordinarily would be the most comfortable place to be. But your anxiety now prevents you from resting. You can pace up and down the room, enter or leave, and none of this will help you. The best way to find relief from your mental suffering is to sit down ... even in such a confused state of mind and in such a bad posture.

SHUNRYU SUZUKI

Thangka, Tibet, 18th century

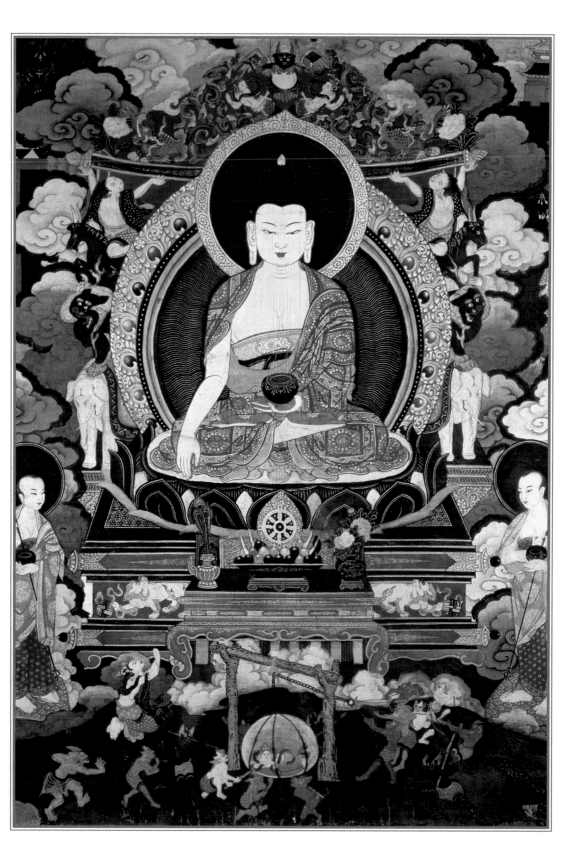

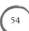

Taming the life forces

During a night of vigil, the Buddha went through all the various stages of meditation. At dawn, he attained Enlightenment and discovered the solution to all suffering. He exclaimed: "The path has been cut off, the dust has cleared: the parched streams no longer flow. With the path cut off, suffering ends."

Just as at the time of his birth, a great number of wonderful phenomena greeted this new miracle, and many gods attended the event. He continued to remain in meditation, but six weeks later, a storm arose. The many-headed king of the nagas, Mucilinda, arrived just in time to protect him from being engulfed.

The nagas are mythological serpents and guardians of the treasures of the underworld. These highly symbolic animals represent the latent forces that sometimes require you to dive back into the waters in order to be regenerated. Many myths evoke these dragon-serpents who keep the threshold of the world sacred. The hero must succeed in vanquishing them, which means he must overcome the murky entanglement of primitive chaos. He must descend into the bowels of the earth, into the rumble of sinister sounds, and into the heat of the underworld; but he then reemerges through the door of the zenith with a crown on his head.

Here, the Buddha joins the ranks of Gilgamesh, Apollo, Jason, and Saint Michael. Like them, in a sense, all men must learn to ally themselves to life's underworld forces.

But notice how the Buddha doesn't kill the serpent, nor does he reject the darkness. The purity of his heart is such that the serpent protects him without even having to confront him.

This lesson is very important. The end of suffering that the Buddha talks about doesn't mean that you will no longer suffer. It doesn't mean that if someone dear to you dies, you won't feel pain. Or that if you fall down in the street, you won't have the slightest bruise. Or that, with age, you won't have an aching back. Even the most seasoned meditator can feel discouragement, fear, or anxiety.

In meditation, we learn to open ourselves up fully to what is and to stop being dissatisfied with our condition.

Don't try to be perfect

There is a certain danger in overemphasizing the calmness and serenity that the practice of meditation provides, making us want to match up to this ideal. But the Way is not to try and be perfect, nor to measure up to some preexisting model, but instead to fully enter into a relationship with what is, including the shadows, the suffering, the accidents, and the misfortunes which make up the thread of all existence. True wisdom doesn't lie in being perfect but in being fully human. The way of the Buddha teaches us this.

Kampong Cham, Cambodia, 12th century

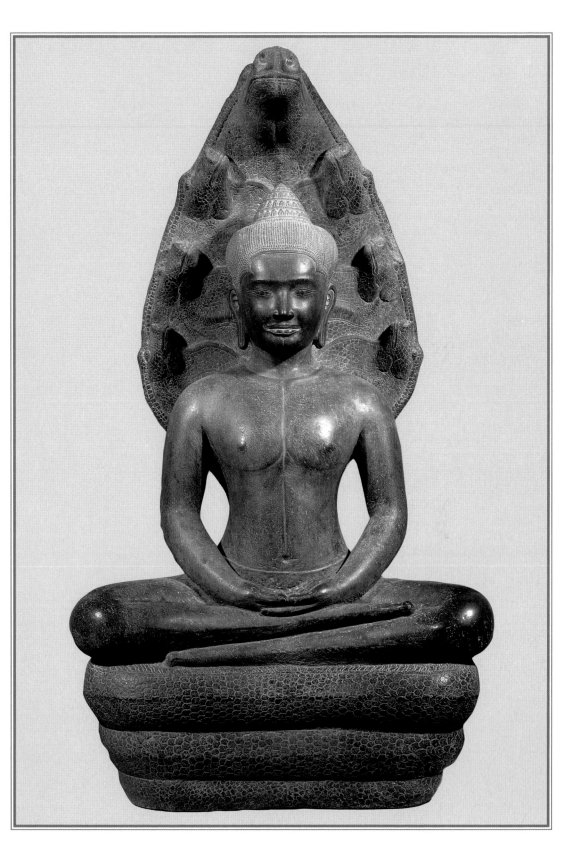

The serenity of the Buddha

The representations of the Buddha are not an attempt to show us what his face was really like. In actual fact, we know nothing of his real appearance. He was probably a man with a thin and vigorous body, but also strong and resistant. His complexion must have been tanned from life in the open air, and he may even have been quite dark. His head must have been neatly shaved in accordance with the rule he himself decreed, and not embellished with flowing hair.

His representations depict the reality of his Enlightenment, a way to show us his accomplishment. They are essentially symbolic. The Buddha's cranial protrusion (*ushnisha*) symbolizes his mental powers; the tuft of hair between his eyebrows (*urna*—often depicted as a round mark or dot), his clairvoyant wisdom; and the images of the wheel on the palms of his hands and on the soles of his feet, the Law. His chest is strong like a lion's; his earlobes are stretched because, long ago, when he was a prince, he wore heavy earrings, but, now unadorned, they represent his renouncement.

Suffused with a profound serenity, his face retains a bright youthfulness.

The image chosen here is typical of the art of Gandhara, a region extending into what is now Pakistan and Afghanistan, and where a representation of the Buddha first appeared. This art was marked, as the face shows, by the influence of Hellenistic-Roman forms, and here the Buddha has a look that is reminiscent of the Greek god Apollo.

Meditation on radical acceptance

Sit yourself down in meditation and simply be attentive to what you feel, without any expectations. Physical irritations may come up, or you could get bored, feel sleepy, or be overwhelmed with various thoughts.

The meaning of meditation is not to live only with pleasant experiences and reject those that aren't. Feel each sensation just as it is. Sometimes it remains, sometimes it disappears, and sometimes it intensifies. This is true serenity—being fully open.

The heart of the practice consists of a "radical acceptance," to borrow the title of the book by Tara Brach. To accept does not mean not doing anything, or being happy with everything that happens, but to be open to what is and to receive it. In other words, accepting a difficulty, a problem, or an injustice is not to find that "it's fine as it is," but to recognize that it's there, before defining the right thing to do. This radical acceptance alone, which is to connect to all that is with attentiveness and benevolence, provides serenity.

Hadda, Afghanistan, 4th–5th century

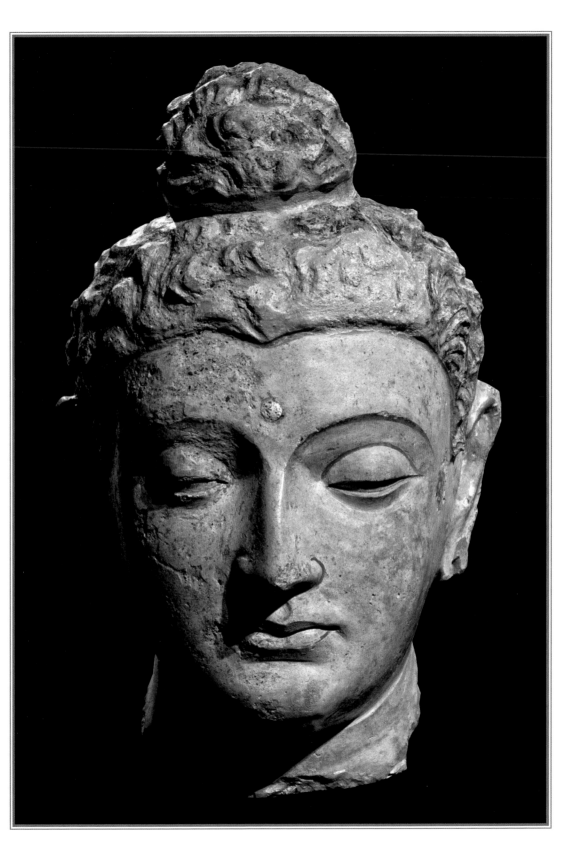

Accepting our imperfections

One big mistake we make is thinking that the end of the spiritual path is to arrive at a state of perfection. Accomplishing this would mean that we would no longer have any faults or notable character traits and would always be calm. In reality, however, spiritual accomplishment allows us to be more completely ourselves and fully accept all that constitutes our uniqueness and the fragility of our humanity.

In this painting, freely reinterpreted in color by the French artist Odilon Redon, the Buddha is dressed in a *kesa*, the traditional garment of Japanese Buddhist monks.

The origin of this clothing is rich in significance. After attaining Enlightenment, the Buddha picked up old shrouds and dirty rags, washed them, dyed them, and sewed them together to demonstrate that the most worthless materials can make the noblest clothing. Similarly, the most wretched being can also rise to become the greatest saint. This Buddhist teaching asks us to work directly with our confusion.

We don't have to be perfect to practice. In fact, we can only practice after accepting our difficulties and our imperfections, with the willingness to work with these.

Fear, anger, confusion, sadness, and anxiety can, paradoxically, help us on the path if we agree to connect to them. The belief that their disappearance would make us better at practicing is a regrettable idea and creates a form of aggression and unnecessary violence toward ourselves.

If you try to transform the weeds of your mental state into fertilizer for your mind, your practice will make noticeable progress. You will see the progress for yourself. You will see how your own fertilizer is made.

SHUNRYU SUZUKI

Le Bouddha (The Buddha), *Odilon Redon, pastel, 1906–1907*

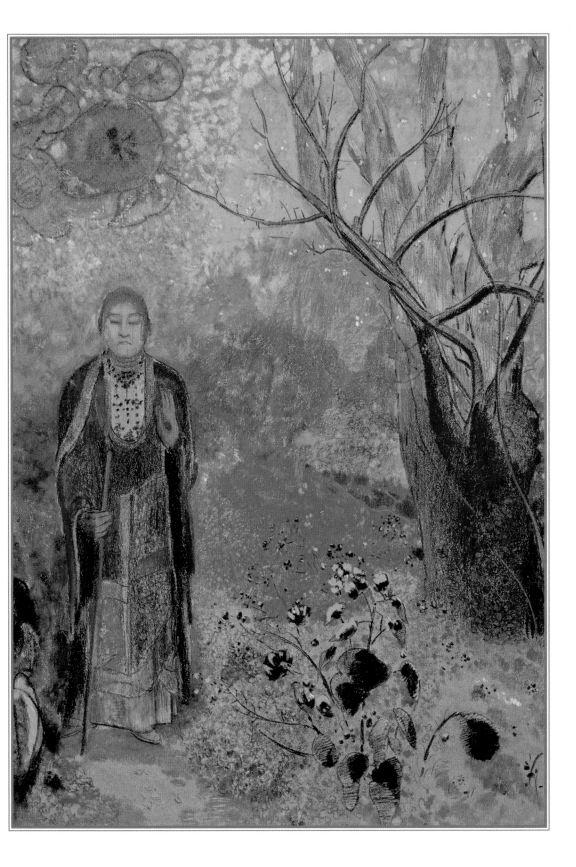

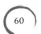

Being present

Buddhism is unquestionably the only religious tradition where the founder is so often represented seated, standing, or lying down without doing anything else. Just his presence is enough to awaken those who see him. Admittedly, some episodes of his life have been represented, but they tend to be minor. This is quite unlike the pictorial economy of Christianity, where a number of events in the life of Christ have given rise to its iconographic representations. Rather than offering historical narratives, Buddhism provides a presence for each era and country to reinterpret according to their understanding of the meaning of the Way.

The Buddha is represented here with his eyes half closed, his mouth hinting at a smile, with an expression that is both gentle and distant. An enormous halo with a floral design frames his head.

The mudra, or hand position, that the Buddha forms signifies that he's setting the wheel of the Law into motion. In other words, he is teaching, as the ancient texts say, "for the relief of a great many men, for the happiness of a great many men, out of compassion for the world, for the happiness of gods and men, to demonstrate the Way, to repress all detractors, for the submission of all demons, in order to produce heroism and activity...."

If you don't find the truth where you are, where do you hope to find it?

DOGEN

There is only one moment in time when it is essential to awaken.
That moment is now.

BUDDHA

WHAT DOES IT MEAN TO BE PRESENT?

Being present is to stop bringing up the past and anticipating the future, in order to place yourself fully in the now. Most of our troubles stem from our difficulty in being present to what is and in being capable of distinguishing reality from what is only virtual or interpretation.

If we are to achieve this, it's best not to be lost in a haze of different thoughts and emotions. In fact, all too frequently we find ourselves on "autopilot," acting mechanically without being truly present.

Meditation practice teaches us not only to return to the present moment, but also to discover that this experience can deepen.

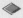

Sarnath, India, 5th century

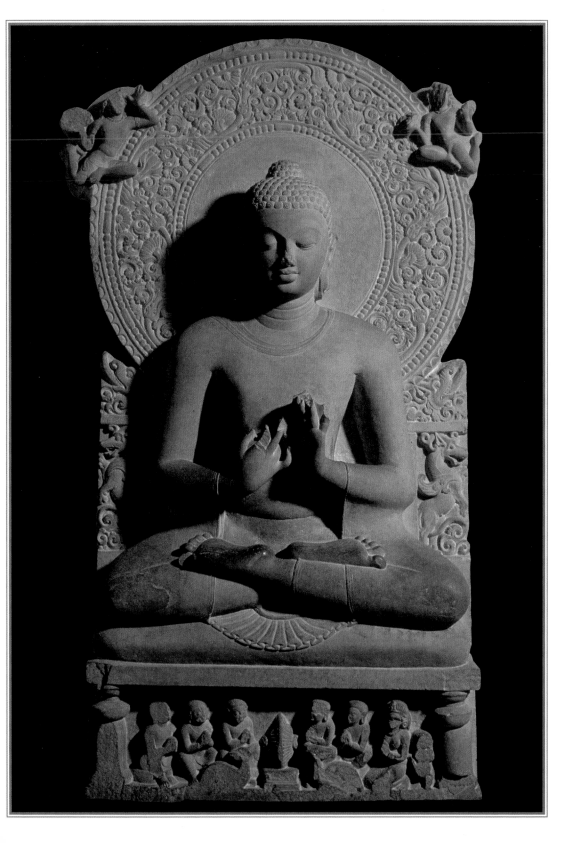

The foundation of the Buddha's teachings

After attaining Enlightenment, the Buddha was hesitant about teaching. "Who would understand it?" he asked himself.

He set off on his way and made a stop at Varanasi, at a tranquil place frequented by deer. He found the ascetics with whom he had previously followed the way of deprivation and asceticism. They were determined not to greet him or talk to him. However, as soon as he approached, all of them stood up spontaneously and greeted him with respect. His presence was so commanding.

They asked him for a teaching. He presented them with his most celebrated speech, now known as the speech from Varanasi, as this was where it was delivered. It contains what is considered to be the quintessence of the Doctrine. Everything is suffering, but we prefer to close our eyes and not see what we feel. We choose to live as if in a dream. Yet it is possible to alleviate this suffering by following the path of meditation, morality, and judgment.

The first of the Buddha's teachings, which asks each of us to recognize the reality of suffering, is very surprising. It is pointless distracting yourself in order to forget the less satisfactory aspects of life or to hide them, as reality will always end up revealing itself. So why not connect directly to it?

For a long time in the West—and this is quite damaging—we considered Buddhist doctrine as being pessimistic. In reality, it's simply filled with common sense. If you go to see a doctor, he would need to make a diagnosis to heal you. The Buddha also is trying to understand what makes us suffer before indicating the path that will heal us.

Meditation on the longing for change

Take a moment to ask yourself about your desire to evolve, change, and be open. Why do you wish for these things? Take the time to truly connect to your longing.

Try it. This little exercise could change your state of mind and put you in touch with your heart.

Are you surprised at what you discover? This is quite normal, as, generally, we don't dare to take the time to reflect on what moves us. In fact, since we often confuse aspiration with plans, we think that our desire for change must go hand in hand with a plan to give us measurable results. Indeed, what would be the point of wasting precious time if we're not going to accomplish these things tomorrow?

This attitude is restrictive. It is actually very important to feel our longing, to free us and allow our skills to flourish. This changes us deeply and allows us to better connect to reality, rather than remaining stuck within the constraints of rigid strategies.

South Korea, 20th century

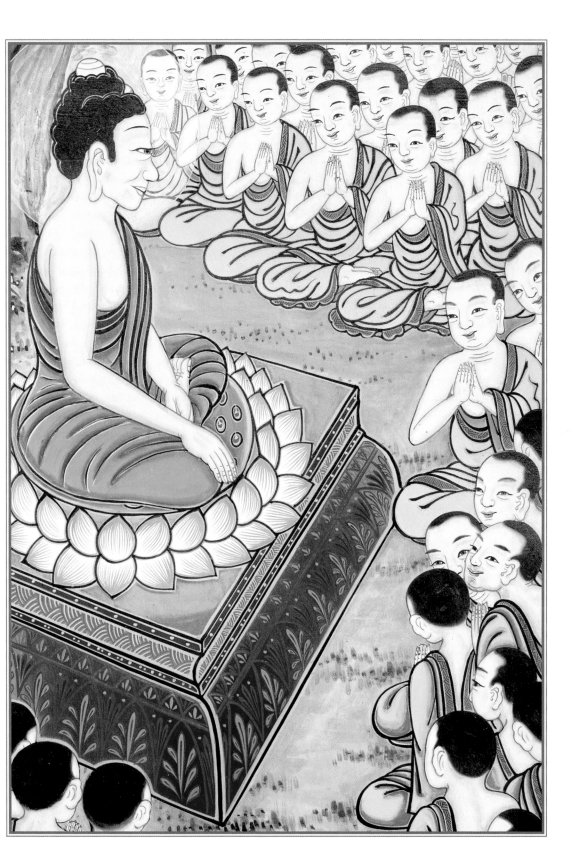

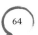

The Buddha, critic of his time

The first disciples of the Buddha were monks. As the Buddha didn't take any account of castes, among them was a barber, Upali, alongside the king of Magadha. All men could become his followers if they wished to walk the Way of Enlightenment.

The community also included women. Five years after the Enlightenment, the Buddha's aunt asked to be ordained. She had shaved her head, taken to wearing monastic clothing, and, together with five hundred women followers, joined the Buddha. By giving the nuns a status equivalent to that of the monks, the Buddha was going against the ideas of his time. In Brahminic India, women did not have the right to recite sacred texts nor learn them.

By quickly condemning the castes and stating that everyone—men or women, Brahmins or members of inferior castes—could enter into the Way, the Buddha was being revolutionary.

And if he came to us today, what would he condemn? What would prevent us from entering the Way? Personally, I believe it's our obsession with profit and our desire for everything to be managed, efficient, and lucrative. I often think that, if the Buddha came today, he would denounce the greed that leads us to destroy the earth and reduce human beings to "resources" which must be managed, just like we manage inventory.

Conscious of the suffering that arises from the destruction of life,
I am committed to developing my compassion and learning ways to protect
the lives of people, animals and plants. I commit myself not to kill, not to
allow killing, and not to tolerate any murderous act in the world,
in my thoughts or in my way of life.

THICH NHAT HANH

Those who teach ethics are like a man who, holding a lit lamp, enters
into a dark house; the darkness disappears and there is light. In the same
manner, when we teach the way, from the moment that the truth is
perceived, the darkness of the ignorant misled by error dissipates,
and there is no one who is not enlightened.

BUDDHA

▶

Gandhara, Pakistan, 2nd–3rd century

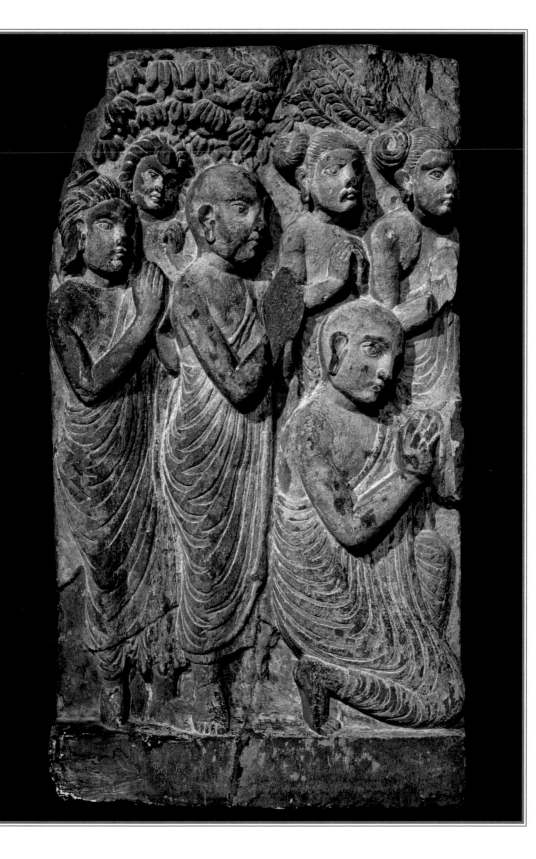

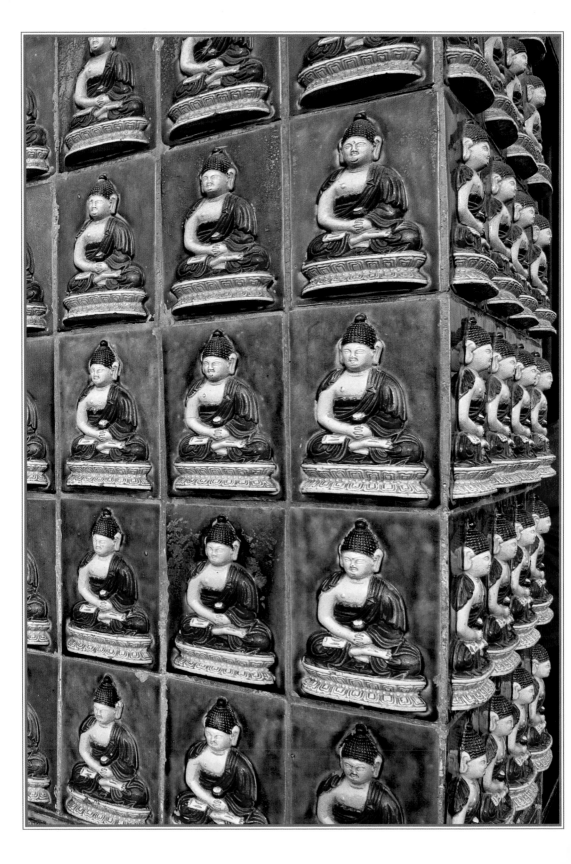

CORRECT BEHAVIOR AND ETHICS

The simplicity of contemplation (meditation—samadhi), clear view or insight (prajna), and correct behavior and ethics (shila) characterizes the way shown by the Buddha. In fact, the main question is in knowing how to behave (shila) in order to keep the meditative (samadhi) aspect of active presence and vibrant openness (prajna).

The Buddha's teaching is not in the slightest about founding morals based on transcendent laws from, for example, God's commandments or Reason. From the Buddhist perspective, behavior is considered correct when it is in accordance with our inspiration, the situation, and when it favors the fulfillment of all beings.

So, unlike ordinary morals based on notions of fault and guilt, Buddhism first of all emphasizes the development of a more sustained vigilance. The man who walks the Way ceases to cause wrongdoing toward others. He no longer creates confusion. It is interesting to observe that, in Greek, the term ethics *goes back to the word* ethos, *which refers to the way you hold yourself and, from this, your behavior, and not to a set of rules.*

In today's world, where meditation is often reduced to a technique for stress management, I think this expression of meditation with ethics and insight that Buddhism teaches us is necessary. Indeed, we could well imagine, as Matthieu Ricard suggests, that a psychopath could decide to learn "attentiveness" to better kill people. This would then be to forget that meditation is, first and foremost, a way of being—simple and open, strong and responsible, benevolent and generous. By turning it into a mere technique, we distort it. We must therefore reemphasize the fact that meditation is not a technique, but rather a fundamental ethical act.

Beihai Gongyuan Park, Beijing, China, 18th century

The great teaching on openness

The first great teaching of the Buddha was delivered in Varanasi, to his former companions. It was on the Four Noble Truths. The second one was delivered on Vulture Peak, a mountain situated close to the town of Rajagriha, in front of a large assembly. Eight years after his Enlightenment, according to Tibetan tradition, this is where the Buddha presented the *Lotus Sutra*. He was no longer presenting the path to renunciation and discipline, but instead the ultimate nature of reality.

The Buddha began in an unusual way, by emphasizing the importance of the words he was about to deliver and the reawakening they would generate among those who would listen to him. Instantly, five thousand monks and laypeople of both sexes, full of conceit, stood up and, after greeting him, left. They thought that they had acquired what they had not acquired and had understood what they had not understood, says the sutra. In other words, they didn't want to be challenged and thought it unnecessary to listen to further instruction.

The Buddha rejoiced that the only ones who remained were those motivated by great trust. Without this—the core of the path—it would be impossible for them to understand this teaching, which went largely beyond those he had so far delivered.

Here, the Buddha undergoes a profound change in his stature. He's no longer a human being who has overcome challenges, but an intangible state of being who lives perpetually and whom we must learn to recognize—and trust—within ourselves. This new body of teachings does not replace the preceding ones, but is an extension of them. He opens up a new era of the Buddha's prophecy which, from that point on, emphasizes the glorious aspect of the Enlightenment and the heroism of the path leading there: it's what we call the path to greatness (*mahayana*—the great vehicle).

Meditation on the Buddha within us

We are all Buddhas who do not know ourselves. Just as the sun always shines, even when shrouded by dark clouds which cannot alter its true nature, our mind is wide open. Confusion, anger, hatred, or jealousy cannot alter its original wisdom. The path does not consist of learning new things or correcting ourselves, but of rediscovering our profound nature.

Meditation must allow us to discover the enlightened quality that is there at every moment of our lives.

Silk painting, Mogao caves, near Dunhuang, China, 8th century

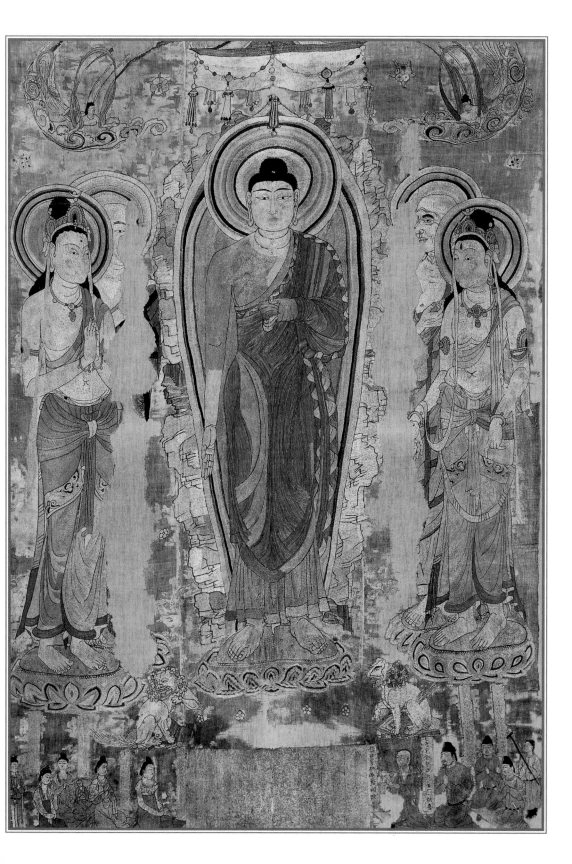

Showing gentleness even when faced with aggression

Even following his Enlightenment, the Buddha continued to encounter conflicts and difficulties. One of his cousins, Devadatta, had always been jealous of him since childhood and wanted to take his place. He suggested that Gautama hand over to him the management of the sangha and go into retirement. Understanding his cousin's selfish and hostile motives, Gautama refused. He publicly declared that, henceforth, Devadatta should be seen as speaking for himself and not in the Buddha's name.

Furious at his failure, Devadatta ordered his cousin's murder. When this attempt failed, he threw a rock on the Enlightened One and yet again didn't succeed in killing him.

A third episode concluded this series of murder attempts. Devadatta made the war elephant Nalagiri furious before setting him loose on the city streets of Rajagriha just as the Buddha was giving alms. But the benevolence of the Buddha immediately subdued this elephant who had sown such destruction and terror in its path. As soon as Nalagiri saw him, his anger dissipated and he knelt before the Enlightened One. This is the last of the four secondary miracles (the four primary miracles being his birth, his enlightenment, his first sermon, and the entry into nirvana).

Devadatta then attempted to create a split in the community, forcing the Buddha to reestablish order once again. All his efforts were doomed to failure.

Meditation on aggression and anger

This act of the Buddha calls for us to free ourselves from anger—which doesn't mean that being angry is bad and that we should prevent it. In fact, if this were the case, we would be afraid of it and would feel bad or guilty whenever it occurred.

We must remind ourselves that Buddhism is not a moral code, but a patient and rigorous study of our imprisonment. It doesn't say to us "don't do this, it's bad," but rather "if you do this, instead of getting what you hoped for, you'll poison yourself and hurt the world."

If someone acts in a way that you find to be intolerable, your reaction will, in actual fact, depend more on your state of mind than on that person's act.

When we feel anger, it's often because we want to punish the person who we believe is responsible for our torment. So we attribute the responsibility of our unhappiness to another, without understanding that the anger is, above all, our own affair, and that it's on ourselves that we should be working.

In these circumstances, don't reject it and don't follow it. Embrace it.

It's very important to understand that you must not repress your anger in the name of some hypothetical ideal of Buddhist wisdom. It will only reemerge even more violently. This is actually about connecting with precision and kindness to ▶

Wat Ko Kaew Suttharam, Phetchaburi, Thailand, 18th century

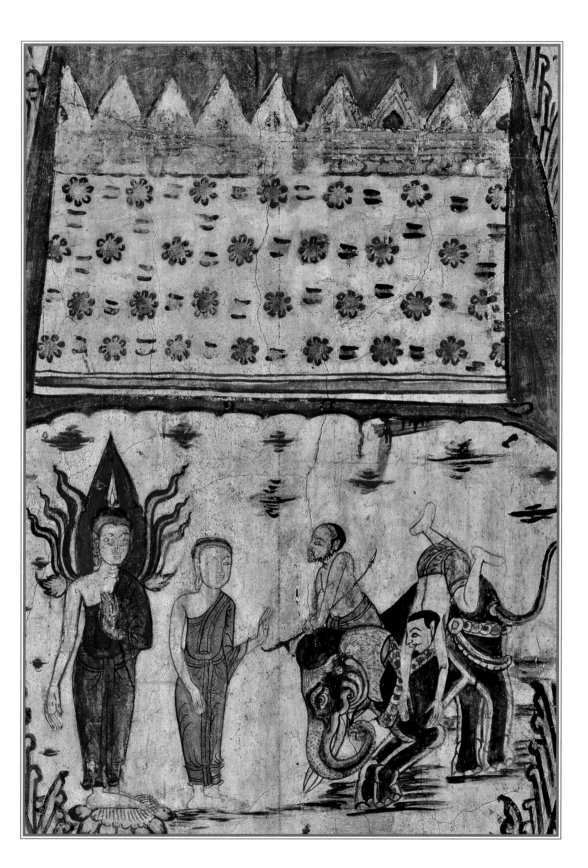

what's happening—to fully examine what you're experiencing and feeling, then releasing it and returning to your seat. Only then will it be possible to know what must be done—whether or not to respond to the aggression or to prevent such an action.

Holding on to anger is like grasping a piece of red-hot coal with the intention of throwing it at someone; it is you who will get burned.

BUDDHA

ABOVE AND LEFT: *Avalokiteshvara Bodhisattva temple, Leh, Ladakh, India, 20th century*

Be your own light

When the Buddha was eighty years old, he fell ill. He had accomplished his work. So he asked his disciples if they still had any questions. Nobody said a word. The Buddha asked three more times if they had any remaining doubts. Silence prevailed all three times. The Buddha knew that he had completed his work, so he took his leave with these words: "Be your own light, take the Doctrine as your light, take no other light, take refuge within yourself, take refuge in the Doctrine, seek no other refuge."

He gathered the community together and urged the monks not to move away from the practices he had taught them. He then announced his departure. To those who lamented, he reminded them that everything is transient: "I am now the bird who has hatched from the egg."

The Buddha didn't show any signs of pain, and Ananda, his cousin and loyal disciple, remarked with astonishment that his skin remained clear and bright. He went toward twin trees and asked for his bed to be placed between them, with his head to the north—where the teachings would spread—and his face turned toward the west. He then lay down on his right side, taking the sleeping lion posture, one foot on top of the other.

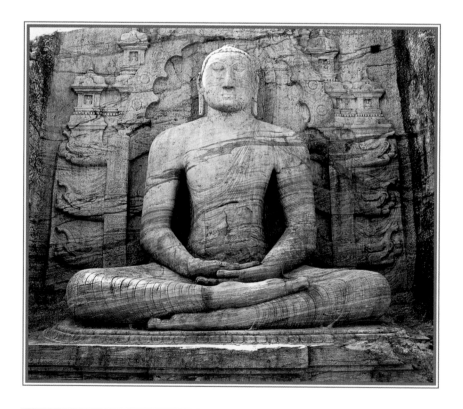

ABOVE AND RIGHT: *Stone temple of Gal Vihara, Polonnaruwa, Sri Lanka, 12th century*

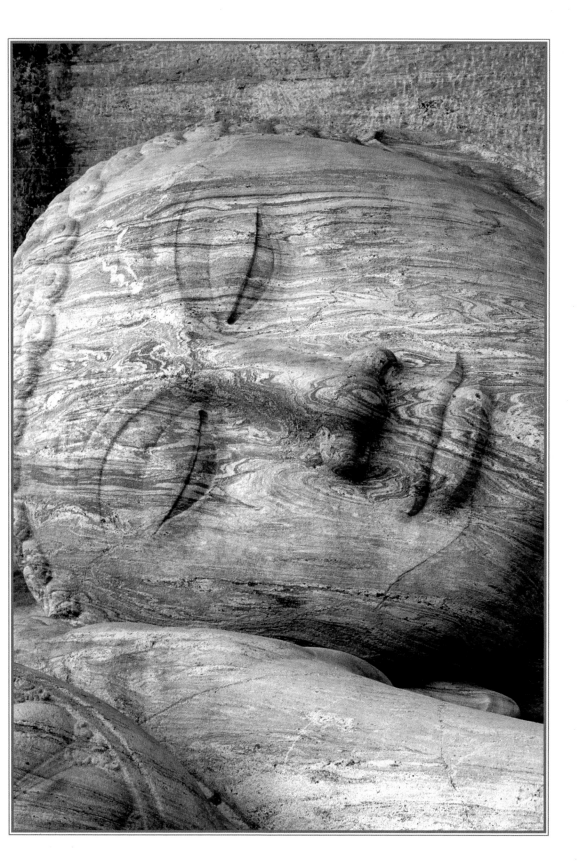

How do we maintain our practice over time?

While the Buddha was still living on this earth, his presence was a source of deep inspiration in helping people to practice with diligence.

How do we do this when he's no longer here?

The stupa, as the ultimate Buddhist structure, represents the Buddha's presence in our world. This form of worship was initiated by the emperor Ashoka in the third century B.C.E. He had a great number of these built in the kingdom. In each, he deposited several relics of the Buddha, placed in sealed boxes under the central dome. Unlike in the Christian tradition, these relics are not displayed to the devotees, but are instead placed inside the monument, like the heart within the human body.

Each stupa is an image of the Buddha and a symbolic representation of the Enlightenment. There are also small versions that can be placed on a temple's altar. Some do not contain any relics, but their characteristic shape is enough to manifest his presence.

Unlike most other places of worship, the interior of the stupa cannot be visited, as its inside is filled. Its function is mainly to encourage a circumambulation in the direction of the sun. Progressively, however, in certain geographic areas, its silhouette has curved toward the interior, even becoming concave, as with the Shwedagon Pagoda at Yangon (Myanmar). Like this, it becomes possible to practice inside the stupa.

Built in honor of the Buddha, stupas confer great spiritual merit on those who take part in their construction. They can be found in all Buddhist countries, where they have quickly become pilgrimage sites. But it's equally possible to represent the Buddha in paintings, to read texts, or use symbolic elements to inspire your practice.

WHAT WOULD HELP YOU MAINTAIN YOUR PRACTICE LONG TERM?

Take something that symbolizes the spirit of meditation. The stupa is perhaps not always adapted to our culture. Some Zen masters choose a beautiful stone or a flower. The idea isn't to feel obliged to follow an abstract ritual, but to find a poetic way to invoke the Buddha's presence, created with gentleness, benevolence, and tenderness.

Stupa, Sanchi, India, 1st–3rd century B.C.E.

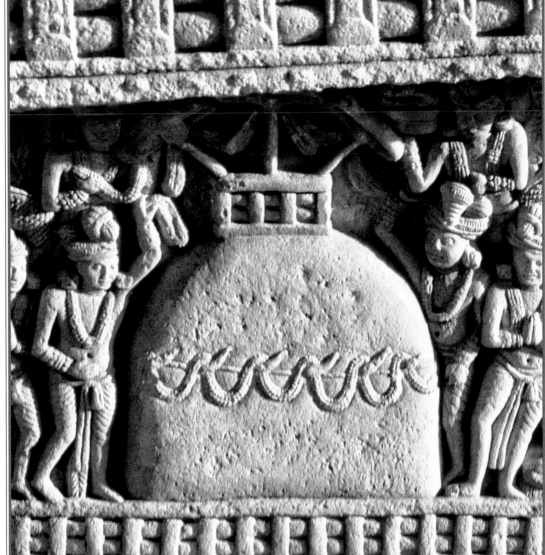

What is attentiveness?

This sculpture has an extraordinary presence, which differs from that of the Buddha. Let's examine this difference. Whereas the Buddha remains in a state of true presence, completely relaxed and benevolent (the Enlightenment), in this depiction of the *arhat*, his disciple, we see a certain effort to be attentive.

An arhat aspires, with great seriousness, to follow the Way, as taught by the Buddha. He stays with this intention, without any attachment or tension. He has left his home, he has been ordained, and the simplicity of his monastic commitment allows him to devote himself entirely, from this point on, to the spiritual way.

The beauty and strength emanating from this Chinese statue expresses the state of personal experience to a commitment such as this, the heart of which is meditation practice. This is how you learn to maintain the state of attentiveness and openness. The person practicing, rather than closing himself off, remains in silence to discover peace of mind and be more authentically human. This presence is filled with an alert intelligence, which unfolds spontaneously and lets you cut through conflicting emotions and egocentricity.

In search of attentiveness

Be attentive to what is happening right now, to what you can hear. Don't add words: a horn, the sound of water, a bird…. In fact, by labeling your experience, you would be limiting its magnitude. Simply try to listen to what is there, like a child marveling at every little thing. This is attentiveness. It keeps what there is without seeking to judge, transform, or seize it.

The practice allows us to see that our attentiveness can be increasingly refined. We can always be a little bit more precise. So, as you pay attention to your breathing, try to follow the beginning of your exhalation, its development, its journey through your body, and its end. Be attentive to each sensation. You'll then discover that the present has a continually new freshness that you can open up to.

The attentiveness we develop in our practice has three characteristics.

First, it's stable and allows us to jump around less from one thing to another. Our mind settles, for example, on a sound, or on our breathing.

Next, the attentiveness is open and not focused. In addition to the sound, we also hear the environment in which it resonates.

Finally, our attentiveness is "immersed." It isn't analytical and doesn't rationalize, by trying, for example, to measure the pitch of the sound, or to breathe in a certain manner…. As Christophe André says, immersed attentiveness "makes us forget that we are thinking or acting."

Some define meditation as being an apprenticeship on attentiveness—which is certainly restrictive, but absolutely correct. In fact, to meditate is to learn how to pay attention.

Glazed tricolor terracotta statue, China, 10th–13th century

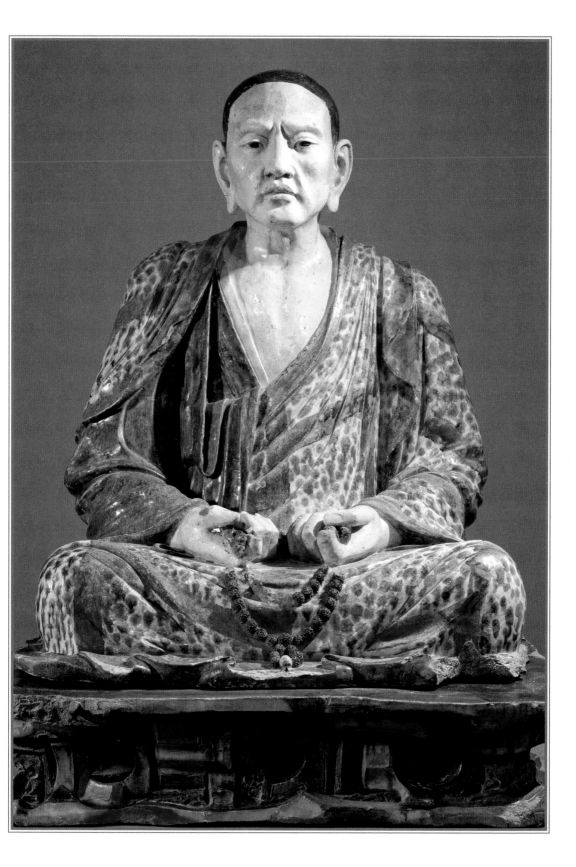

On the joy of meeting a teacher

The arhats—"those who are worthy of respect"—are Buddhist saints who have flawlessly accomplished the teachings of the Buddha. They've long been considered as examples of the perfect disciples.

When the Buddha left the earth, a legend tells us that he named those who were to preserve his Doctrine from among his disciples. The number and names of these arhats vary, depending on the country. In China, there were eighteen, whereas in Japan and in Korea, there were sixteen of them. These arhats were responsible for preserving the Buddha's teachings, even in times of religious corruption or political crises. Some texts also entrust them with the mission of gathering the various relics of the Shakyamuni.

The arhats were respected as witnesses to the Doctrine's continuity. Here, the arhat is shown teaching in a Chinese landscape, signifying the continuity of its transmission from India to China, where the Buddha's words could be heard from then on.

In fact, in every era, there are people who embody the truth of the Doctrine and who are a profound source of inspiration.

How do we recognize a true teacher? Don't look for a perfect person. The benchmark is that, when he speaks, we *know*. Listen to your intuition, avoid the places that try to impose things upon you, and go to a place where every person is encouraged to be who he is.

Surmang Monastery, Tibet, 17th century

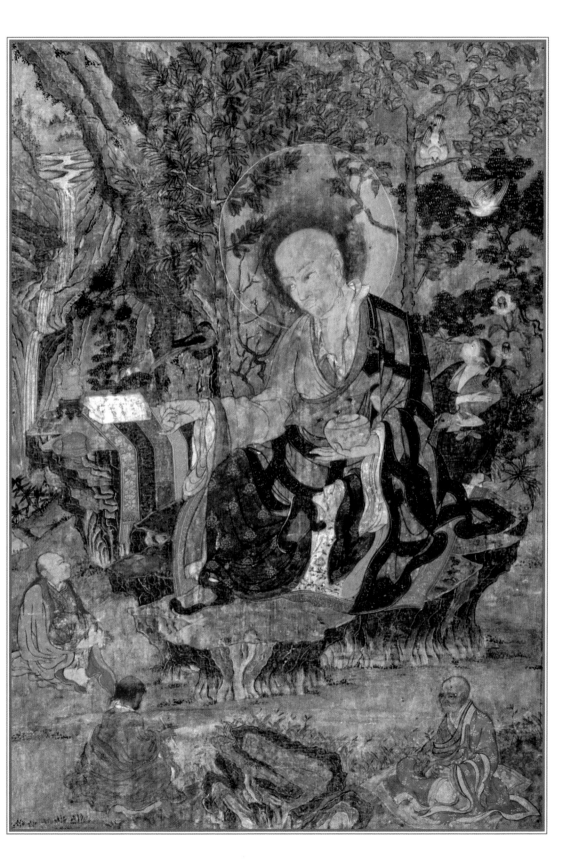

How to overcome hatred

The representation of the arhats is not symbolic, as it is for the Buddha, where each characteristic refers to a teaching point on the meaning of meditation; it aims to characterize various personality types.

In China, it is the custom to represent them as eccentric figures. These paintings allowed for exercises of virtuosity where, with a few lines, a particular temperament could emerge. Their aim was to create a more direct and personal connection with the teaching.

Depending on the country, the thirteenth arhat has different names: Angaja, Ingada…. He was considered the one who diverts those snakes which may bite passersby. After catching them, without hurting them, he removed their poisonous fangs and then released them back into the mountains. In the same way, he removes confusion and hatred wherever they are, not in order to destroy the person who is inhabited by them, but to make them more free.

> *In this world, hate never yet dispelled hate.*
> *Only love dispels hate.*
>
> BUDDHA, DHAMMAPADA 5

Meditation on hatred

Although this is undoubtedly the Buddha's best-known phrase, we don't adequately appreciate the tradition of the Buddha as, first and foremost, being the way of love. However, this love is not the sugary sentiment or the excitement to which our culture unfortunately all too often reduces it, but a rightful weapon against hatred. According to the Buddha, we're wrong when we try to respond to evil with evil, and to hatred with hatred. The Buddha doesn't condemn hatred because it could be a sin, but because it doesn't accomplish what it claims to do. It makes us believe it will give us peace by destroying what provokes us, when in fact all it does is poison things. Dissolving hatred doesn't consist of fighting against it, but looking at it just as it is, each time it arises.

We're therefore asked not to chase away hatred and anger, not to deny them, not to forbid them, but just to take a good look at them—meditatively. This is the only way they can be disarmed. Let's emphasize this idea: it isn't about always being "kind" or never reacting to violence, but about engaging with hatred in a kind way. A serious mistake is in believing that we shouldn't, in the name of love, relate with hatred and regard it in all its horror. On the contrary, it's about challenging hatred with an open and attentive attitude in order to better disarm it.

Ink and color on silk, Samgaksan, Seoul, Korea, 16th century

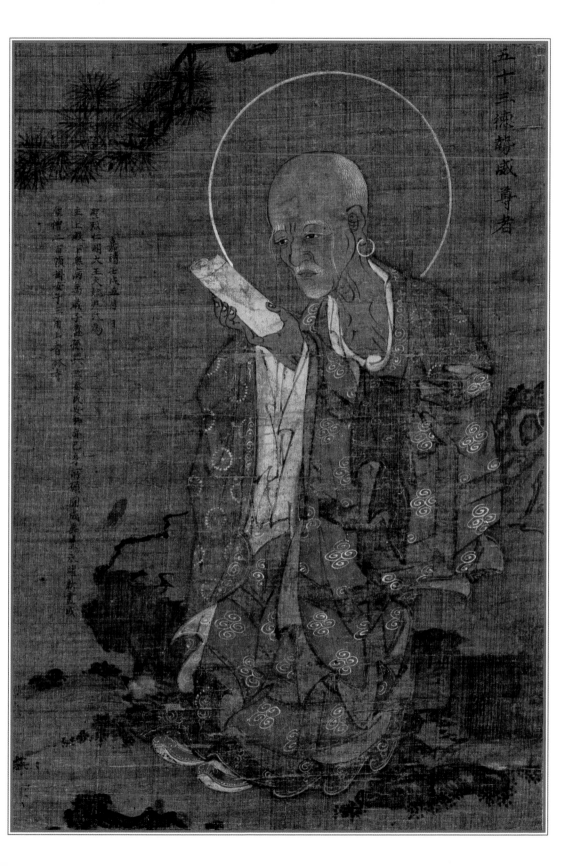

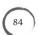

Perseverance

Before becoming a prince, the Buddha lived many lives in which he manifested his wisdom and love for all beings. These numerous tales, called the *Jatakas*, are a way to connect the legends of secular literature to Buddhism. All it took was to turn the animal, man, or god in question into one of the Buddha's ancestors. These stories—547 of them, according to the Pali canon—all ask us, in one way or another, to cultivate an altruistic and generous attitude.

In one of these stories, the mother of Mahajanaka, the king's wife, was forced to run away from the kingdom after her husband's death. Her son, when he turned sixteen, decided to recapture it. He fitted out a boat with seven hundred men, but a tornado sank it. He swam for seven days and seven nights without losing heart and with intense ardor, while all the others perished. A sea goddess, surprised to see him swimming like this in the middle of the ocean, asked him why he continued to swim when he couldn't see the coast. The prince answered that it was the duty of all men to surpass themselves. So she led him to the shore from which he could recapture his kingdom, which he renounced some time later in order to devote himself uniquely to the practice of dharma.

This story highlights the virtue of perseverance.

How to persevere with meditation practice

As touched on previously, for successful long-term practice, it is better to practice regularly, even just a little, rather than sporadically and for a long time. Meditating, even if only for fifteen minutes a day, can greatly improve the quality of your life. But this has to become a habit. And, as it often takes several weeks before we feel the benefits of meditation, our motivation is likely to weaken.

In order to keep our motivation intact, we need to reflect on the meaning of the practice, the reason for committing to it daily, and to the changes it's going to bring into our lives and the world. The practice then ceases merely to be a technique to be followed and takes on its full significance.

It can be good to take advantage of guided meditations that can be listened to at home (in the form of CDs or downloadable audio files). Rather than wondering what we should be doing, these simply let us follow directions, moment by moment.

It can also be helpful, sometimes, to practice in a group, provided the group meets our needs and we feel at ease there. In fact, when several people practice together, a certain communion takes place. We have a common experience, but without, at the same time, losing connection with our own solitude. It's a very powerful experience, when we feel connected to others sharing the same aspiration without being overcome by the group setup.

Finally, a longer meditation session from time to time, whether taking a course or on a retreat, can allow us to breathe new life into our practice.

Painting on dried lime plaster, Ajanta, India, 5th–6th century

I lack nothing—or, the art of overcoming dissatisfaction

The Buddha liked to tell the story of Mandhata, a rich and prosperous emperor who governed the world for centuries. Having been satisfied by all the desires known to man, he became dissatisfied. So he decided to leave for the celestial world, which seemed to him to hold spiritual pleasures superior to those he had known so far. However, after some time, he began to feel dissatisfied yet again. He then wanted to go to the top of the heavens, where the king of the gods received him and offered to share his throne with him; this is the moment represented in this second-century artwork.

The two protagonists are seated comfortably on their throne, surrounded by women, many of whom are playing musical instruments.

But even this joy ended up boring Mandhata, who returned to earth, where he grew old and died.

The Buddha told this story to show us that, even if we could satisfy all our desires, we would still not be happy. It's preferable, the Buddha advises, to stop this infernal pursuit, which deprives us of the possibility of celebrating what is, and to stay in a state of simplicity and peace. Always wanting something else cuts us off from ourselves and from reality. This is not about giving up on all of our wants, desires, and commitments, but to put an end to this incessant compulsion that diverts us from the true source of happiness.

Meditation to overcome dissatisfaction

I say to you: there is no Buddha, there is no Law; no practices to cultivate, no fruit to try. Just what are you seeking from outside? How blind you are, putting a head on top of the one you already have! What do you lack?

Lin-Ji

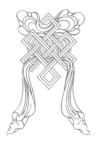

Great stupa of Amaravati, India, 2nd century

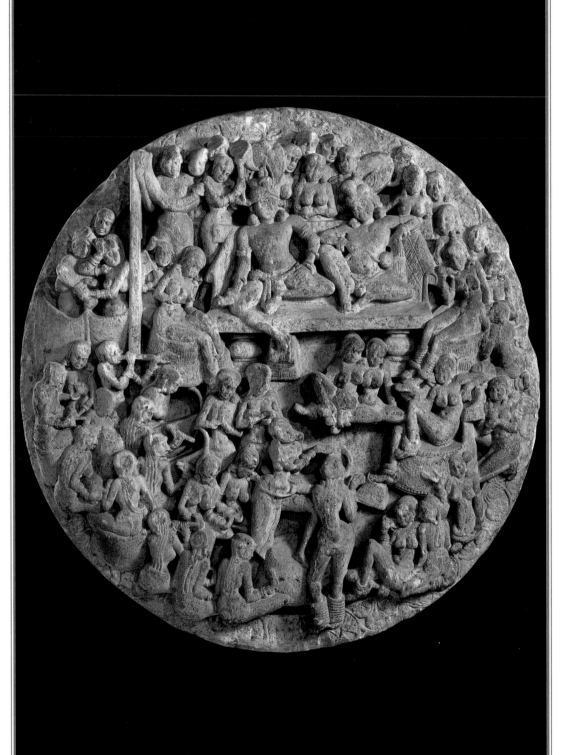

The giving that frees

Here's another story taken from the *Jatakas*: a monkey-king lived with his subjects in a forest at the foot of the Himalayas. They all fed themselves with the delicious fruit from an enormous tree. Its branches were so massive that they made it look like a mountain. The king asked his subjects to be careful not to let any fruit drop into the water, knowing that if that happened a great misfortune would occur. One day, however, a piece of fruit became detached and fell into the Ganges, which flowed below. The current dragged it along to one of the tanks belonging to the sovereign of Varanasi, who was bathing there. He had never seen such a fruit. On tasting it and finding it exquisite, he wanted to find the tree that had produced it. His quest was a long one. When he finally saw the monkey-people enjoying these fruit, he was seized with anger. He wanted the fruit for himself alone. So he ordered his archers to massacre all the monkeys at dawn.

Realizing the fate awaiting his subjects, the monkey-king used his own body to make a bridge between the two banks of the river. He thus prevented the death of the monkeys. At dawn, one of them, drunk with jealousy, decided to break the bridge by jumping on his back. The sovereign of Varanasi witnessed the scene. He saw the monkeys departing and found the great primate exhausted, suspended from a branch. It was the Buddha who, in a previous life, had manifested his gift of generosity; the wicked monkey was his cousin Devadatta. Moved by his tireless enemy, the monarch asked two of his servants to spread a blanket to cushion the fall of the generous monkey-king.

Meditation on giving

The Buddha is teaching us about the giving that frees. We generally don't give for the pleasure of giving, but, as Chögyam Trungpa points out, "We sometimes give because we want to break free from something. Or else, we give at specific times, such as Christmas or a birthday. Sometimes we give a present as a sign of appreciation, to thank someone who's given us something, such as their affection, advice or support. But it seems like we never give without an objective or a plan. We don't give just to give." The practice of giving consists of giving without philosophical or religious reasons, and without expecting anything in return. Such a gift is a profound act of letting go that opens up our heart and mind.

By giving, we become less self-centered and more open to others. We've all, for example, experienced offering something to someone dear to us just for the pleasure of seeing them happy. This kind of attitude is deeply freeing. We actually then discover that we have unexpected inner and outer resources. This can, of course, be surprising at first, but try it and you'll see: the one who gives discovers that he is the one who is rich. As for the one who doesn't know how to give, who's afraid of loss or worried about not having enough, he will find that, even if he happens to be a millionaire, in reality he's poor. His mind is poor.

The practice of giving teaches us the meaning of true wealth, which has nothing to do with the quantity of goods we possess. True wealth depends on a ▶

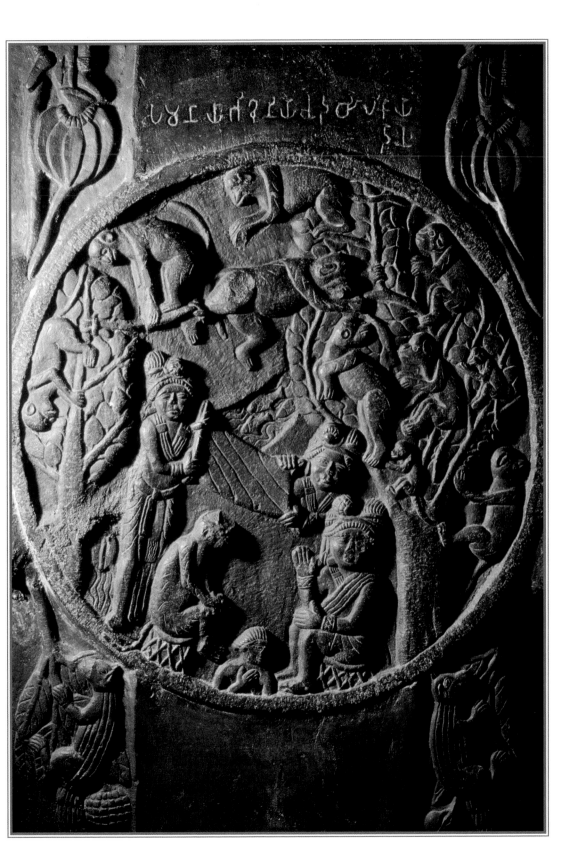

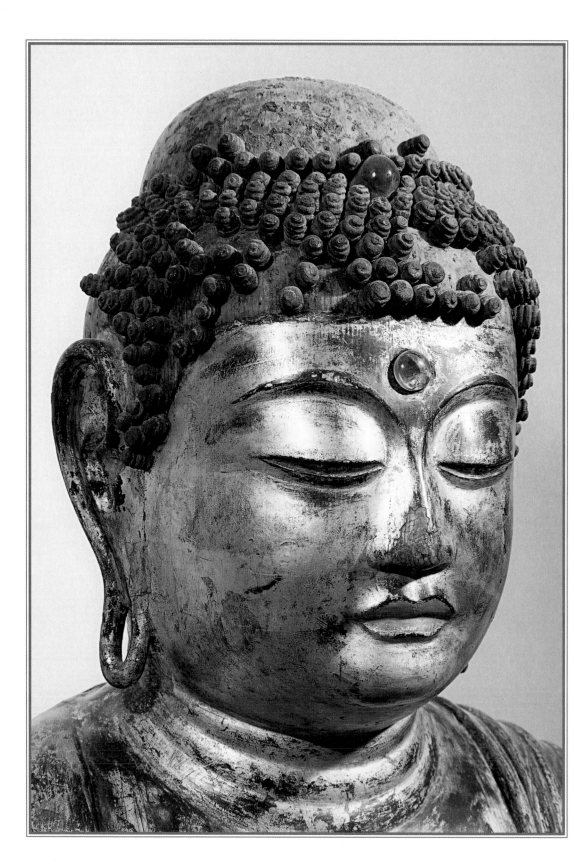

state of mind. And the wonderful thing is that giving is something we can learn. It's a practice.

However, it isn't enough simply to give something to truly give. In fact, some people, who feel they are not well-liked, give because they hope to be viewed with higher regard. Or simply because they don't want to say no.

In order for the gift to be complete, we need to reflect on our motivation—on what we feel when we carry out a particular act and what makes us do it. Is it to be open or is it out of fear, attachment, or the desire to please?

The Buddha's teachings, as you have seen, are not moralistic. It's not about "giving because it's bad to be selfish." Buddha tells us to give to be more at peace and to have less of a need to defend ourselves.

Japan, 11th–12th century

PART II

The path of benevolent love and compassion

"Having meditated on gentleness and on compassion,
I have forgotten the difference between myself and others."

<small>MILAREPA</small>

In Part I, we followed the path to freedom taken by the Buddha, which each one of us can also take.

Now, we go on to examine the aspects of the Buddha showing benevolent love and compassion.

As a teacher of meditation for many long years now, I have been impressed by the importance of passing on two kinds of meditation. The first kind—the one on attentive presence or mindfulness—allows us to return to the present moment with the help of attentiveness. It constitutes an actual philosophy of presence: how to be and how to behave.

The second kind consists of discovering that this presence is not empty, cold, and uninhabited, but loving, warm, and open. And that it invites us to open our hearts and act for the benefit of others.

If we're to learn to live in the present, we also need to feel the warmth of benevolent love and pay more attention to the suffering of others and of the world, so that we can respond to it.

Does this mean that love and compassion can be learned? This concept often surprises those who practice, who are generally convinced that love is something inevitable. We are, in fact, confusing passionate and destructive love, made up of attachments and expectations, with authentic love. While the former often falls upon us, the latter requires intense training.

This is what the poet Rainer Maria Rilke refers to in *Letters to a Young Poet*: "For one human being to love another; that is perhaps the most difficult of all our tasks, the ultimate, the last test and proof, the work for which all work is but preparation."

The Buddhist tradition has a wealth of remarkable thoughts on ways to love better—not just the loved one, but also all beings.

It is to this exploration that I now invite you. You will see that this journey is full of surprises and precious discoveries.

On the importance of our motivation

Avalokiteshvara is one of the principal bodhisattvas, a term that could be translated as "heroes of Enlightenment." The bodhisattva in effect dedicates himself to all beings through a gesture of great heroism. So long as human beings continue to suffer, he renounces his own attainment of freedom (nirvana/buddhahood).

Driven by such ardor, bodhisattvas are represented not as ascetics, but rather as glorious and majestic princes. Beautiful and embellished with jewels—necklaces, bracelets, earrings, belts—they wear a loincloth, a tiara, and sometimes the Brahmin thread. They are distinguished by great finesse and a delicate appearance. They wear a topknot and an *urna* adorns their forehead. Isn't this a beautiful way to represent the ardor of perfect compassion!

Meditation on compassion

What can we take away from this? That compassion is the source of life and accomplishment! Any act motivated by selfishness only limits our life. We then live meanly and in a destructive way. True joy comes, on the contrary, from our capacity to open up and from when we try to make our aspirations as great as possible. This aspiration, exemplified by Avalokiteshvara, is nothing but authentic compassion.

We generally do not understand the word in this way. For most of us, compassion is mainly a religious or moralistic notion. We should be less selfish and think of others. Avalokiteshvara therefore shows us that compassion is not some kind of relentless duty; instead, we listen to the desire that motivates us. Faced with someone's distress, have we all not, at some point or another, felt the desire to end this suffering? Compassion consists simply of expanding this wish. The image of Avalokiteshvara shows us the beauty of such an aspiration, which, though we may have forgotten it, resides in the heart of every being.

All the joy the world contains
Has come through wishing happiness for others,
All the misery the world contains
Has come from wanting pleasure for oneself.
What good are long explanations?
The childish act in their own interest,
The Noble for the good of others;
This is what distinguishes them!

SHANTIDEVA

▶

China, 10th–13th century

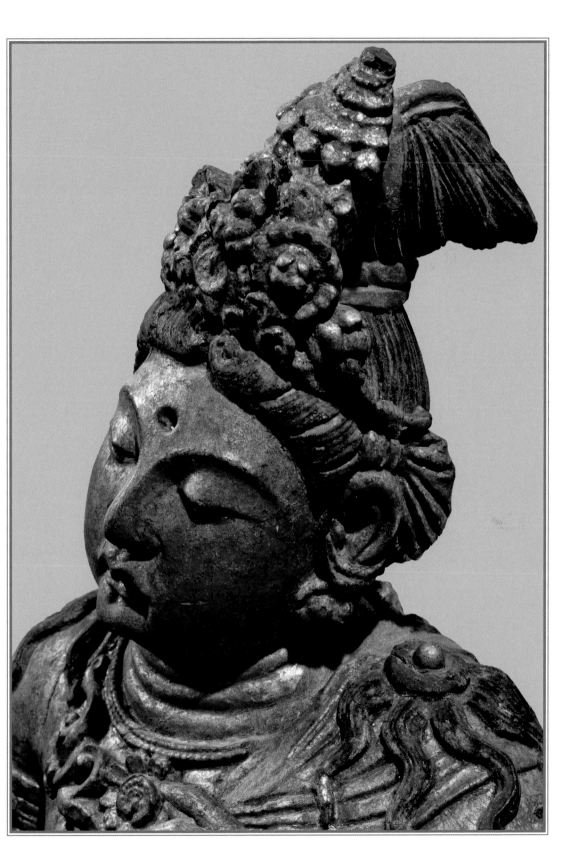

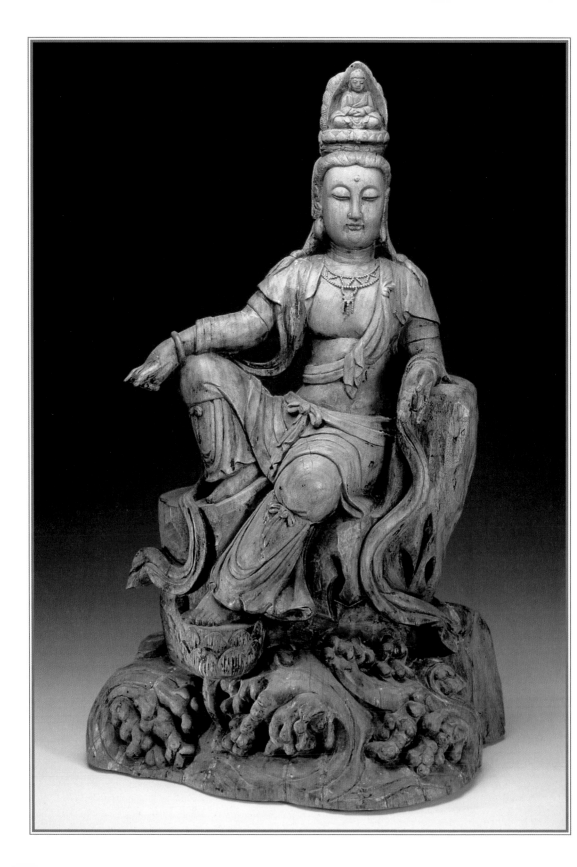

Practice on training for love

Think of someone close to you: a child, your partner, or someone for whom you have feelings of tenderness.

Take your time to feel their presence—for example, by looking at their picture or thinking about their qualities. You could also think about a moment when this person affected you.

Feel your kindness toward them. Let yourself be immersed in this sentiment.

To help you experience this more deeply, you could say a phrase such as: "May you be happy," or "May you be in peace." You could repeat this phrase by paying attention to the meaning of each word.

When we first begin to practice, staying in benevolent love can sometimes seem artificial, like having to smile at someone painting our portrait. In fact, this isn't about forcing ourselves to feel an emotion, but creating conditions that are favorable for their arrival. It's enough to direct your attention to certain thoughts and wishes in order for the practice to gradually become effortless and natural. What is artificial, however, is to think—often over and over again—about pointless things or remain focused on our problems.

WHY DO WE SPEAK OF BENEVOLENT LOVE AND NOT JUST LOVE?

Many people think that love creates a form of dependence, and that we love only if we can get something out of it. Benevolent love has nothing to do with this.

The love that Buddhism shows us is open and vast, and can grow endlessly. It's benevolent because, instead of demanding something from the other person, it's their happiness that is important to us; because, instead of wanting to possess them, we feel responsible for their well-being; because, instead of expecting some gratification from them, we give with joy.

While love is just as often confused with an emotional state, the love we're talking about here goes together with a profound openness of mind. It's a way of saying a complete and deep "yes" to what is. Each time I say "I love you," I rejoice in the simple fact that the other is just as they are. Such a love excludes any demands without counting that it warms all that is isolated and cold within us, and that it is open.

In other words, it isn't the intensity of the love that makes for its authenticity, but its profound quality.

◆

China, 19th century

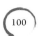

The nobility of the heart

From the beginning of Buddhist iconography, Avalokiteshvara has been one of the most frequently represented figures and can be found all over Asia. In Sanskrit, his name is composed of *avalokita* ("one who observes") and *Ishvara* ("lord"). He is therefore the "lord who observes" and doesn't leave anyone out of his gaze. He manifests, in this way, the ideal of compassion, which is to take care of all beings, leaving no one in distress.

Our compassion is often limited because we feel it for certain people but not for others. It isn't perfect. But it does exist within each of us. And, even if this frame of mind only manifests for one single person, it means the seed of compassion is already there. It's on this basis that we can work to increase it and make it impartial, to include all beings, without distinction. This is the example set by Avalokiteshvara for us to follow: to increasingly open our hearts.

The calm attitude we see in this sculpture is often described as "royal ease." Free of all tension, having gone beyond all worry and strain within himself, Avalokiteshvara manifests a peaceful elegance. With perfect gentleness, benevolent love accomplishes what it must, whether at the top of the world or in the depths of suffering.

I find the ease on this face highly illuminating. There's a great lesson there. For most of us, compassion is often linked to suffering and despair. As for ease, it would often imply letting go, carefree behavior, or a manner of "taking a vacation." In this instance, ease is an act of great nobility, aiming to pacify and help all those who need it without at the same time losing confidence.

May I be
For the sick
The remedy, the doctor and the nurse
Until all sickness disappears!

May I calm with a rain of food and drink
The pain of thirst and hunger,
And, in the age of famine,
May I myself turn into food and drink!

SHANTIDEVA

Practicing equanimous love

Take a moment, as you did previously, to feel tenderness for someone close to you. Feel your desire for this person to be at peace, happy, and free of all torment.

Then extend this thought to all those who are close to you, by saying, for example: "May every one of these people also know true happiness." Take the time to be truly conscious of your wish by letting your words resonate.

▶

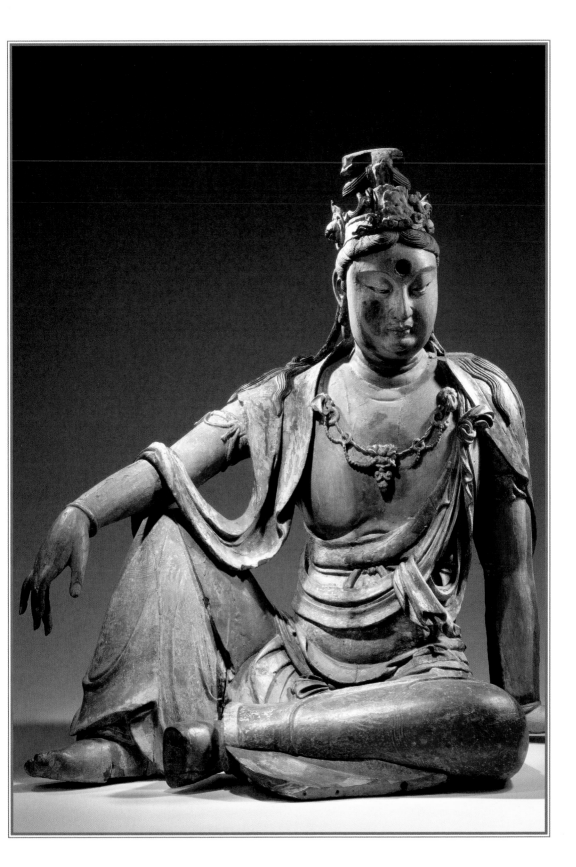

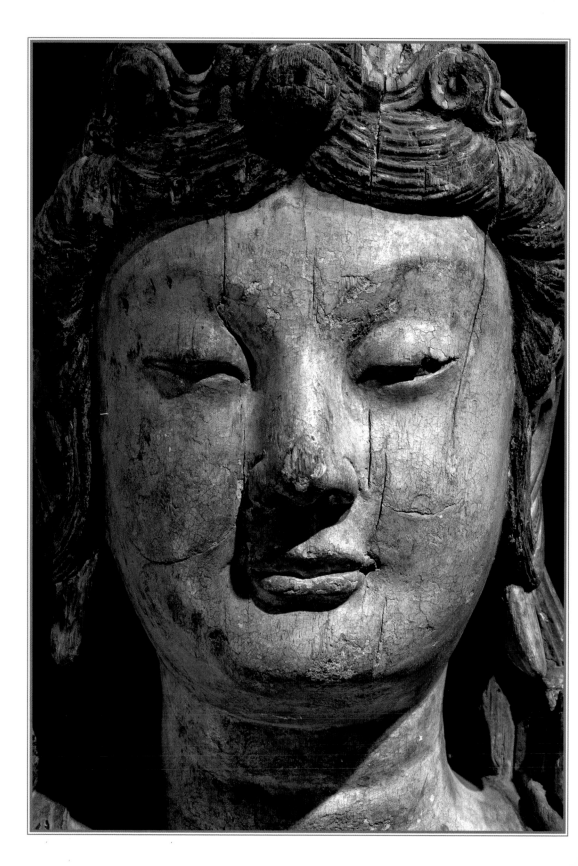

Then try to do the same thing for those you know less well—for instance, people you may come across regularly but don't really get on with.

And, finally, try extending this thought to all beings.

The practice implies wishing peace equally on our enemies or enemies of humanity. In the latter case, it obviously doesn't mean you wish success for their destructive and harmful plans. It's about wishing for them to abandon hate, cruelty, and indifference, so that benevolence and the concern for the happiness of others may arise in their minds. As Matthieu Ricard explains: "The more serious the sickness, the greater the need for care, attentiveness and benevolence."

In this practice, you must be like the sun that lights up everything without discrimination, whether it's a magnificent landscape or a pile of waste. Your love must light up all beings.

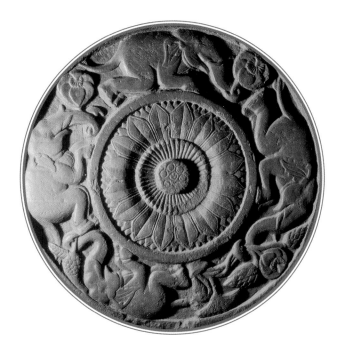

ABOVE: *Stupa, Barhut, India, 2nd century* B.C.E.
LEFT: *Multicolored wood statue, China, 10th century*

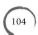

Benevolent and tender love

This is one of the most memorable paintings in Indian art. It dates back to the fifth century and comes from the Ajanta caves, which were discovered by accident in 1819 by a captain of the English army who was out tiger hunting.

Padmapani, or the "one who holds a lotus in his hand," is the figure represented here and a manifestation of Avalokiteshvara.

His face, gazing downward, has a pensive expression evoking the deep tenderness of someone who knows just how hard life's challenges can be. Padmapani welcomes pain, anxiety, and worry, just as they are. We can clearly see here that the Buddhist ideal has little to do with withdrawing into a state of beatitude, but involves instead opening up the heart, leaving it exposed and, in its most poignant vulnerability, in contact with all the world's suffering. Such is the true heroism embodied by Padmapani, and to which we are invited.

His elongated eyes, accentuated by the sinuous line of his eyebrows, turn toward the world, which is worthy of his most tender attention.

How do we ourselves develop this attitude?

In Buddhism, benevolent love and compassion are not presented in the form of moral commandments. They're seen as the natural development of our own hearts, which we must learn to pacify.

The task isn't always easy. We sometimes feel so hurt and in conflict with ourselves! This is particularly true in today's society, where all forms of kindness are considered a sign of weakness. We're supposed to control ourselves, restrain ourselves, not let anything show, be a "superman" or "superwoman."

This type of attitude is extremely severe. As a result, whenever we feel miserable or anxious, we tend to blame ourselves, and sometimes even get angry with ourselves. Our frustration then intensifies, and it becomes a vicious circle.

What should we do? Stop judging ourselves, assessing ourselves, and pressuring ourselves, and instead open up to what we are, completely. Grant ourselves the kindness and tenderness that we would give to a dear friend. In fact, we are often more ruthless with ourselves than with anyone else.

Adopt Padmapani's gaze

Find a way to say out loud the goodness you wish for yourself. You could use the following phrases: "May I be happy"; "May I be healthy"; "May I be at peace" … Choose whichever of these suits you best and which expresses your deepest wish. Repeat it gently, again and again. Take the time to truly feel the sentiment within your body. Physical anchoring is very important for this.

With this mental stance, you may sometimes feel a lack of benevolence. You may even be overwhelmed by a strong feeling of unworthiness. If this happens, don't blame yourself. Accept this feeling. Remind yourself that you've committed to a practice. It isn't about accomplishing something, but about working with the difficulties that arise. Be kind toward your impression of not succeeding. ▶

Mural painting, Ajanta, India, 5th–6th century

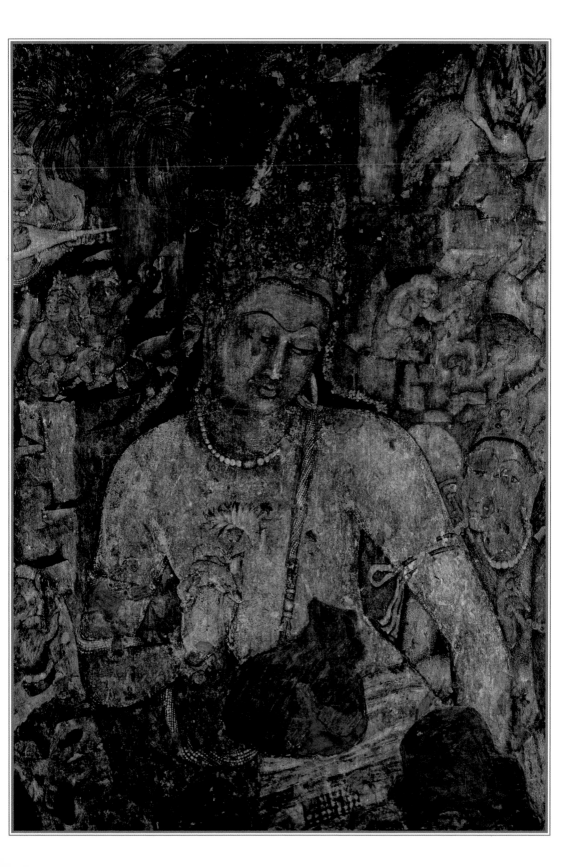

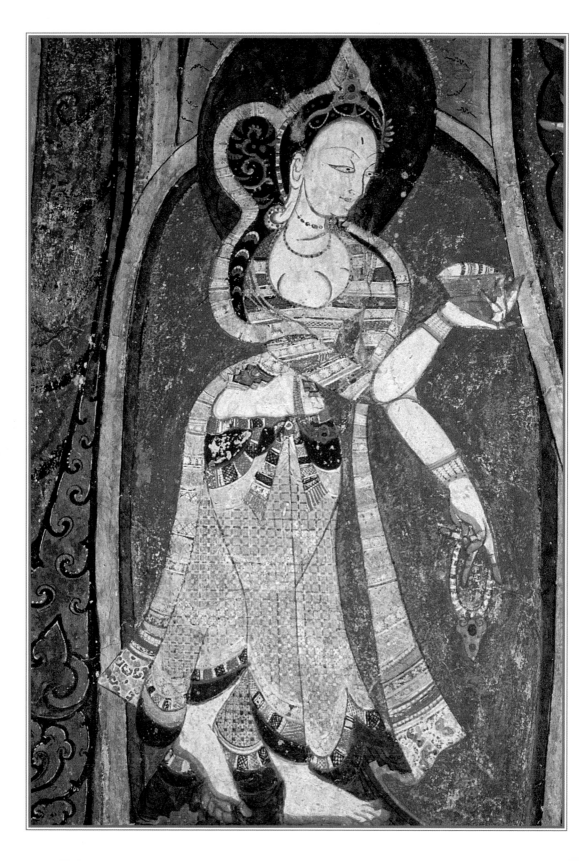

Don't transform this practice into a new obligation.

It takes time to overcome so many processes and habits, so much suffering and violence.

We must be willing to be completely ordinary people, which means accepting ourselves as we are, without trying to be bigger, purer, more spiritual, more insightful. If we can accept our imperfections for what they are, quite ordinarily, then we can use them as part of the path. But if we try to get rid of our imperfections, they will become our enemies, obstacles on the road to our "self-improvement."

CHÖGYAM TRUNGPA

THE DIFFERENCE BETWEEN BENEVOLENT
LOVE AND COMPASSION

The Buddhist tradition distinguishes between benevolent love (maitri) *and compassion* (karuna).

Benevolent love here consists of wishing happiness for everyone. By "happiness," Buddhism is not referring to a passing state of well-being or a pleasant sensation, but a profound realization of our own humanity, involving inner freedom, fortitude, and a true vision of reality.

Compassion is the form love takes when confronted with suffering. Buddhism defines it as "the wish for all beings to be free of suffering and its causes."

In other words, in benevolent love I wish for the other person's happiness in the strongest sense of the term, while with compassion I wish for them to be relieved of all torment and free of all suffering.

◆

Alchi Gompa, Ladakh, India, 10th century

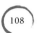

Seeing clearly with compassion

Avalokiteshvara made a vow to save all beings. He promised that if he were not able to keep his word, his head would explode into a thousand pieces, like a common coconut. For a long time, he devoted himself intensely to the good of others. But one day he told himself that all his efforts were meaningless, as countless beings continued to suffer. He felt discouraged. It was at this precise second that his head exploded.

This is compassion without clear vision and without wisdom. It doesn't know what to do.

Amitabha Buddha, to whom he had made the vow, decided to gather the scattered pieces. But, so that the bodhisattva could be even more powerful and have even fewer reasons to be discouraged, when the fragments were gathered together they formed eleven heads, which could then look more easily in all directions. To be better able to help all those who call on him, Avalokiteshvara was also given eight or a thousand arms, depending on different versions of the story.

This is a very valuable lesson. Authentic love is inseparable from the sharpest intelligence. Avalokiteshvara is not a "Care Bear." He isn't naive. His love isn't blind, but intelligent: he sees with his eleven faces, and he isn't powerless, blessed with all those arms. This image shows the deep meaning of love that the practice asks us to cultivate.

We tend to be wary of love because we're afraid that it could make us set aside the demands of truth and justice. We believe, for example, that it's linked to a sentiment needing to be tempered with reason.

But the lesson here is that love is, in itself, pure intelligence. A nonintelligent love is not love! To love is always an act of intelligence.

What is clear vision?

Clear vision consists of understanding the situation in which we find ourselves and knowing the best way to act, especially by asking ourselves: "What are the benefits and disadvantages, in the short and the long term, of what I'm about to do? Will my action affect a small or a large number of people?"

Clear vision also involves recognizing our error when we take the idea of one illusory self facing another, which produces either desire or aversion. We then mistakenly have the impression that we're separate from others, that the other is a stranger to us. As those who practice Buddhism would say, Avalokiteshvara then remains hidden within us.

When we experience benevolent love, we're not separate from others. During the bloody attacks on Paris in November 2015, for example, many people felt wounded by what was happening. They had the intense desire to do something, to relieve the suffering. This illustrates that benevolent love does exist, even if we forget this, all too often, while we remain isolated, trying to find some unobtainable sense of safety.

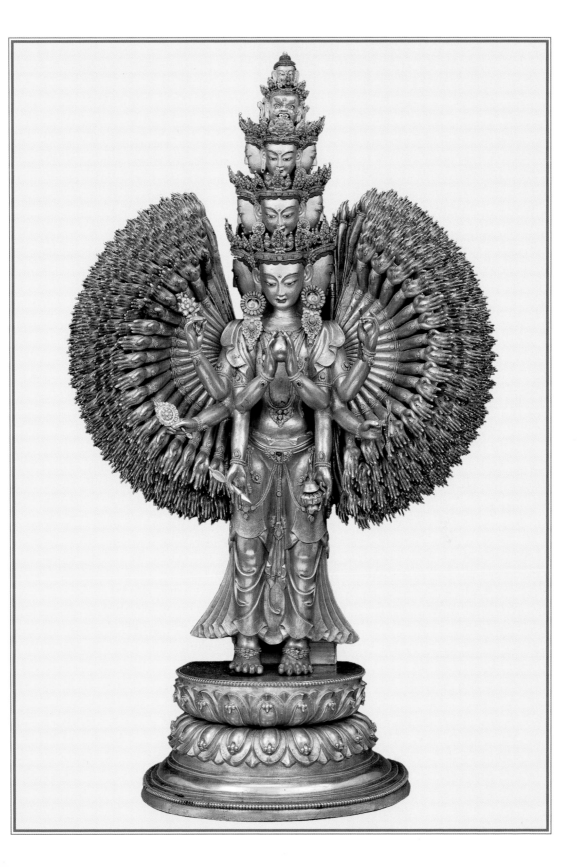

Compassion to guide our souls

Avalokiteshvara is generally shown in the masculine form embodying the stable and strong aspects of compassion. In India, he's often depicted with a thin moustache and clearly defined chest muscles. But in the Chinese and Japanese traditions, from the seventh century onward, he's represented in the female form.

This dual tradition pleases me a great deal. It differs, according to the speech, as to whether the love is considered more feminine or masculine.

In this painting, Avalokiteshvara shows compassion, as it emerges at the moment of death to lead the deceased to a peaceful place of love. But it could also emerge in critical moments, to appease destructive passions.

Just as, with her own life,
A mother shields from hurt her only child,
Let all-embracing thoughts
For all beings be yours,
Love the entire world,
Above, below and all around, without limits
With benevolent and infinite goodness.

BUDDHA

Meditation on love to heal our turmoil

In this practice, begin by feeling your pain, which is not always evident. Often, we refuse to admit to ourselves just how much we're suffering.

Simply take the time to feel whatever is hurting you. This could be an irritation you felt today or something older and more serious. What do you find painful, right here and now? Initially, try simply to be present for this experience. And most of all, instead of blaming yourself, welcome the pain just as it appears. Greet it. Trying to crush, deny, or reject it will only aggravate things.

You could, if it's helpful, place your hand on your heart and say the words: "May I be at peace and not blame myself."

One of the benefits of this practice is allowing us not to always expect help from the outside. Far from making us more selfish, as many would think, it actually makes us less preoccupied with ourselves and more available. In this sense, as Kristin Neff points out in her book *Self-Compassion*, self-compassion is distinct from self-esteem.

The compassion that is never discouraged

One of the most impressive representations of Avalokiteshshvara is where he's shown with a thousand arms. The number one thousand symbolizes the limitless compassion of the bodhisattva, who can see all the suffering of the world all at once (with his thousand eyes) and come to their aid (with his thousand hands). He is often represented with forty-two arms (symbolizing a thousand of them): two with their palms joined, and the other forty fanning out around his body.

What does this manifestation of compassion signify?

Every time that Avalokiteshvara—the compassionate love within us—comes across some difficulty, a sickness, an accident, or a violent act, the impact awakens his compassion and produces another arm.

Every time we're hurt by suffering, Avalokiteshvara is there—with the dignity of an open heart that is never discouraged.

> *As long as space abides,*
> *And so long as the world abides,*
> *So long may I abide*
> *Destroying the sufferings of the world!*
>
> SHANTIDEVA

DISTINGUISHING EMPATHY FROM COMPASSION

Empathy involves entering into an emotional alignment with the feelings of another. It isn't enough by itself. It doesn't know what to do. It could therefore lead to a person feeling overwhelmed by the suffering of someone close to them or someone else, or by the suffering of the whole world. This is what we sometimes refer to as "burnout" or emotional distress.

Compassion consists of the intense desire to ease suffering. It isn't reduced to an emotional dimension. We're therefore not just open to suffering: we also have the desire to do something. Compassion is therefore inseparable from the full and sincere drive and concern to understand a situation in its entirety. In fact, we can only ease suffering if we're capable of understanding what needs to be done in such a situation.

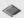

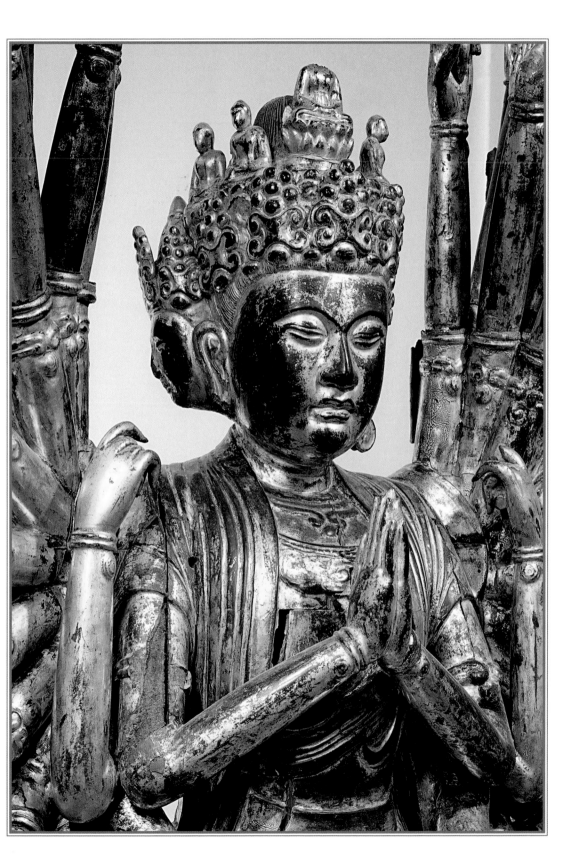

Attentive listening

In Japan, Avalokiteshvara has taken on a feminine aspect and is called Kannon—"one who listens with care." Why did Kannon take on this name? In Sanskrit, *Ishvara* means "lord," but the term was understood to mean *svara*, noise or sound. Kannon thus became the one who listens to all the prayers directed to her and to all the cries of pain from those in the earthly realm. What more beautiful way to understand the deep meaning of compassion than as the attentive openness and ability to respond to all suffering?

There are thirty-three forms of Kannon, reflecting her ability to provide the most appropriate kind of help to those who need her. Here, again, we see that compassion is inseparable from the subtle understanding of a situation. Because, when someone is suffering, helping them—and knowing what needs to be done—demands extraordinary perceptiveness.

This is the face of compassion that offers help in even the most difficult of situations.

Meditation to overcome the feeling of isolation

Whenever we're in pain, we tend to believe that we're the only ones suffering in this way and that other people have some kind of gift that we have been denied. We're inclined to compare our being, which we see as weak and fragile, to others who we see as being happier and more competent than we are. These people may even appear to be a threat to our well-being.

In this situation, we need to practice compassion and take a moment to make ourselves aware of our desire to free the world of its suffering. The result won't take long: our feelings of isolation will subside. Whenever we think of other people's suffering and wish for this to diminish, we leave our ivory tower and become more human.

▶

WHY HAS BUDDHISM GIVEN RISE TO SO MANY DIFFERENT FIGURES?

Just as an ocean has many characteristics—humid, salty, vast—the spirit of Enlightenment also has different aspects: compassion, wisdom, correct conduct, generosity, courage....

Compassion itself can take on many faces: gentleness, the commitment to free the suffering, the most loving benevolence....

The multiplicity of the Buddha's faces does not in any way alter their unity.

◆

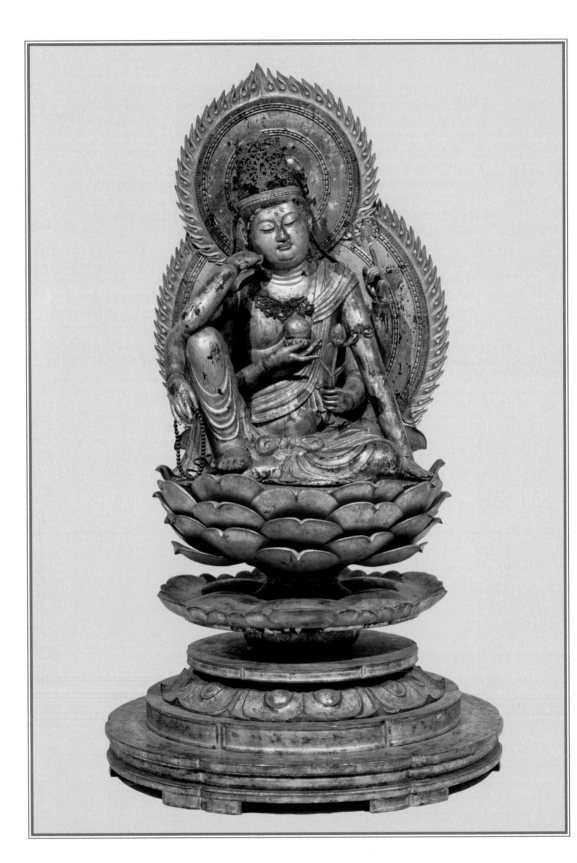

WHAT IS CONCERN FOR OTHERS?

Our belief that we're separate from each other is an obstacle to understanding concern for others. In fact, we have this false idea that we are isolated beings who must choose either to connect to other people or not. If Paul and Marie love each other, for example, it isn't really so much about Paul, who loves Marie, and Marie, who loves Paul, but about love making them what each one of us is. In other words, Paul isn't Paul without Marie, and Marie isn't Marie without Paul. Indeed, if one of them disappears, they will not only feel they have lost their beloved, but also that they are no longer themself. It is in love, or in a relationship, that we become who we are. We were not that before then. In other words, the relationship comes first.

This is one way of showing what Buddhist teaching calls the nonego: the fact that nothing exists independently, but always in relation to something else.

Concern for others has two aspects. On the one hand, it involves being open to what the other is experiencing: I must be sufficiently attentive to feel what that person is experiencing. And, on the other, it requires us to want to take care of that person and do what is necessary to ease their suffering.

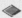

The selfish person is like the tortoise who transports his house on his back wherever he goes. We must, at a certain point, leave our house and go out to meet a wider world.

Chögyam Trungpa

Wood and gold leaf, Japan, 10th century

The accomplished female

Tara is one of the female faces of the Buddha. She is pure intelligence, the intuition of reality's ultimate nature, pure emptiness and naked openness. And, in fact, it is only in this complete openness that the Buddha—or presence and benevolence, understanding and gentleness—can arise.

She is also a bodhisattva—that is to say, an ordinary being who made the vow of commitment to free the world.

In order to accomplish her vow, she committed herself to the Buddhist path, involving meditation, training toward correct behavior (ethical code), and discernment. The monks who met her, struck by the brilliance of her accomplishment and limited by their social preconceptions, wished for her to have a man's body in her future lives. She refused this and answered:

"Here, there is no man, no woman,

No self, no individual and no categories.

'Man' and 'Woman' are only labels

Created by the confusion of the world's deceived minds."

Facing the crude conceptions of these monks, she decided that, since few women in those days had the possibility of practicing, she would do good in the world in a female form. Her practice allowed her to accomplish her vow.

Since the time of the Buddha, the Buddhist tradition has granted women full opportunity to take the path, in an era when they were confined to subservient activities.

THE PLACE OF WOMEN IN BUDDHISM

One of the Buddha's revolutionary acts was considering that women could enter into the Way, which was totally revolutionary in the Buddha's time. During his lifetime, many of his disciples were in fact women, including nuns and laypeople. And it was a woman—Sanghamitta, the daughter of King Ashoka—who introduced Buddhism into Sri Lanka.

Then, as it spread, Buddhism developed the idea of the lack of gender differentiation, fundamental to the Buddha himself. Although the ancient texts presented the Buddha as a "Great Man," from then on, all beings—from the moment they attained Enlightenment—could manifest as both female wisdom and masculine spirit.

Finally, there have been many female masters of great importance, especially in the Tibetan tradition.

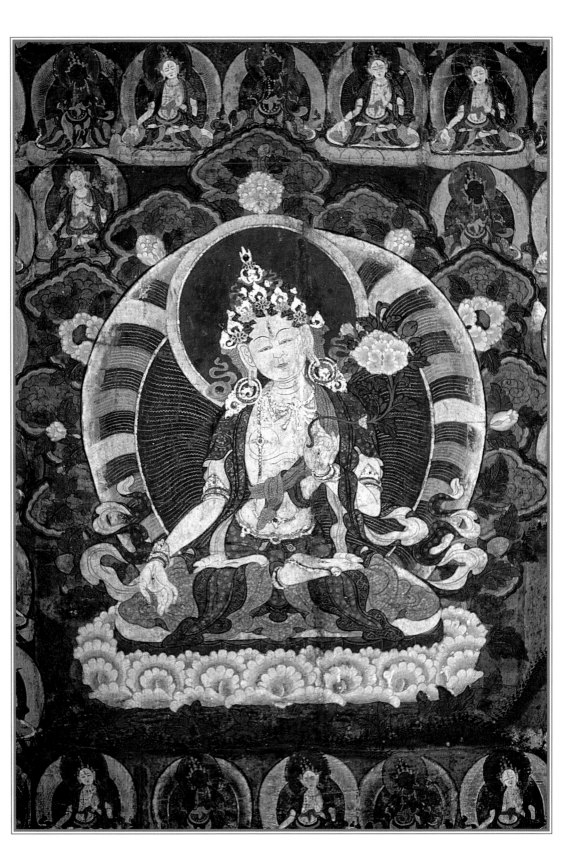

Universal and resourceful love

There are two main forms of Tara: the white liberator and the green liberator.

In her white form, she has seven eyes: three on her face, one on each of the palms of her hands, and one on each of the soles of her feet.

She is the one who saves us with universal and resourceful love—the all-benevolent. The songs of praise about her are very moving:

> *Homage to the Liberator, swift and fearless,*
> *With eyes like a flash of lightning,*
> *Lotus-born in an ocean of tears*
> *Of Chenrezig [Avalokiteshvara], the three worlds' Protector.*

> *Homage to her whose face is like*
> *One hundred autumn moons gathered,*
> *And blazes with the dazzling light*
> *Of a thousand constellations.*

By reciting these praises, we generate within us the call to liberate love.

Meditation on the jewel in the heart

Just as every sesame seed contains some oil, every being has within himself the potential for Enlightenment. But due to not recognizing, or having confidence in, this concept, he ends up wandering in confusion. We are, like in one of those old stories, similar to the beggars who don't know that there is treasure hidden at the foot of their bed or in their shirtsleeves.

The Buddhist path directs us toward finding this treasure, thus giving our lives fuller and deeper meaning.

The Tibetans emphasize the fact that even the cruelest animals feel tenderness for their young. All of us, at some time or another, have been moved by something: a mother's love, the caring act of a friend or stranger, an encounter with a wounded dog. This shows that our heart cannot remain insensitive. Compassion consists of cultivating this tenderness that is inherent to our existence and stopping trying, as we usually do, to cover it up, hide it, or run away from it.

This experience we all have of being moved by someone or something is particularly illuminating. Compassion isn't necessarily a pleasant experience, as it requires us to expose ourselves, to get out of our comfort zone, to be affected and hurt, even occasionally by someone else's pain. This is why the Buddha shows us a path allowing us to be more loving and compassionate.

Mural painting, Tang dynasty (618–907), Tibetan school, Tibet

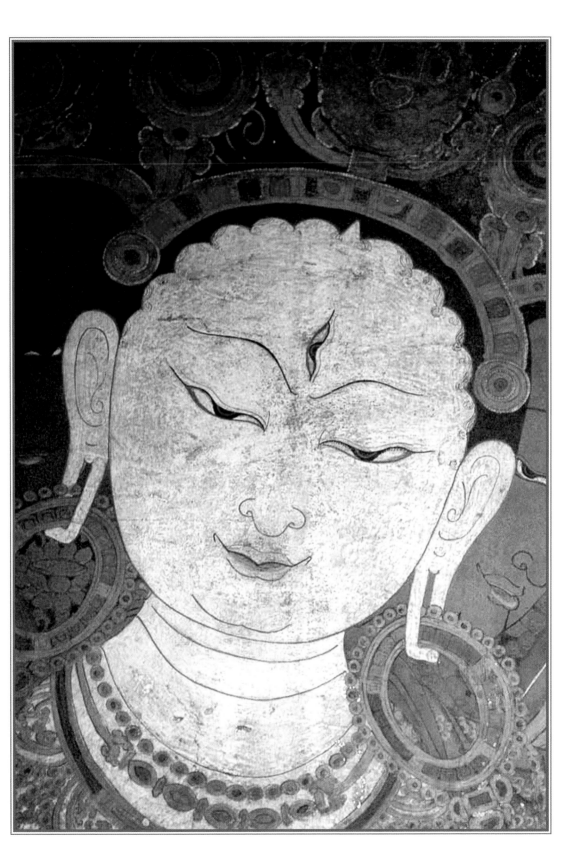

Effective compassion

Tara is said to have been born from a tear of Avalokiteshvara, the bodhisattva of compassion. This is a symbolic way to say that she represents the essence of compassion—the effect of being moved with the greatest intensity by the concern to ease the world's suffering—and is the embodiment of it.

When Tara is green, she has two eyes and sits with her right leg out in front of her. Her color symbolizes the enlightened activity of effective compassion. She acts for the good of all who invoke her with the speed of the wind.

The folded left leg represents the renunciation of vulgar attachments, and the right leg, half folded, shows that she's ready to rise and save the world.

Meditation on the world's suffering

Take the time to contemplate the world's suffering. Think of all beings who are suffering at this moment: those who are sick, those who are isolated, those who are ill-treated, and those who have nothing to eat. It isn't about punishing yourself, but about turning your heart toward all beings and letting the ardent desire to help them emerge.

When we turn away from suffering and remain absorbed in ourselves, life withers away. We commit acts that we then regret. In fact, simply being aware of other people's suffering and difficulties allows love and compassion to emerge spontaneously within us.

Instead of cherishing ourselves, we cherish others;
Then we just relax.
That's all. It's so very simple.

CHÖGYAM TRUNGPA

WHY MEDITATION IS AN ALTRUISTIC ACT

It is sometimes believed that those who practice meditation are being self-centered and indulging in a kind of egocentric introspection, rather than taking care of others. In actual fact, the aim of all meditation is to succeed in eradicating self-absorption and cultivating a world where benevolence and compassion have their place. Negatively judging the time taken to meditate would be, as Matthieu Ricard points out, similar to reproaching a future doctor for spending years studying medicine.

It's a mistake to liken meditation to a tranquil calmness. In reality, meditation requires courage. It even represents a form of heroism.

Tibet, 19th century

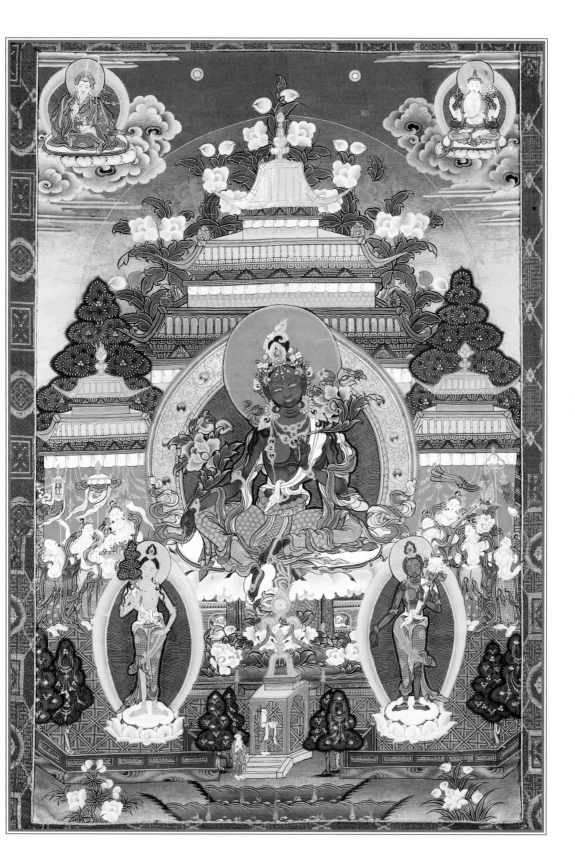

The jewel and the lotus

Back when Tibet was inhabited by demons, Avalokiteshvara, filled with compassion for this desolate earth, manifested himself there in the form of a monkey. There, the monkey-bodhisattva mated with a demon, the ogress of the rocks. From this union were born six monkeys without tails, forming the six tribes or clans constituting Tibet. The Tibetans, not very charitable toward themselves, recognize that, although they're sometimes motivated by the compassion passed down from their ancestor Avalokiteshvara, they also have the mood swings and belligerent character of their ancestress, the demon.

In the Tibetan language, the name Avalokiteshvara is Chenrezig, the Eye who sees accurately, and he who looks at all beings with the eye of compassion. Avalokiteshvara is considered the country's patron saint. The Dalai Lamas are worshipped as his incarnations, and their palace, the Potala, is thought to be a replica of the one belonging to Avalokiteshvara.

His mantra *Om Mani Padme Hum*, repeated at every opportunity, can be seen engraved on many stones and mountains.

Meditation on the reciting of the mantra

The mantra *Om Mani Padme Hum* is another way of naming Avalokiteshvara: "he who holds the jewel and the lotus."

The jewel is the pure love we carry within us, most often without even knowing it, while looking elsewhere for what could fulfill us. We lose sight of the fact that what we're looking for is already inside us.

The lotus, which grows in the mud and yet radiates with beauty, is the symbol of the heart's purity. If compassion, like the lotus, arises from suffering, then when it does spring, it will be just as pure and noble.

At first, reciting a mantra may seem strange. It's as if we are repeating someone's name again and again. But, for Buddhists, this name is none other than that of Avalokiteshvara himself. Reciting this mantra is therefore a way to immediately get love and compassion to spring forth.

For most people, this practice won't seem natural. They will prefer to invoke love for themselves, for those close to them, and for all beings. For others, chanting this mantra allows them to truly inhabit the dimension of benevolent love.

The important thing is not to follow rules, but instead to look for what is most helpful and, in this way, find one's own path.

Temple of Tongbang-Sa, Korea, 10th–12th century

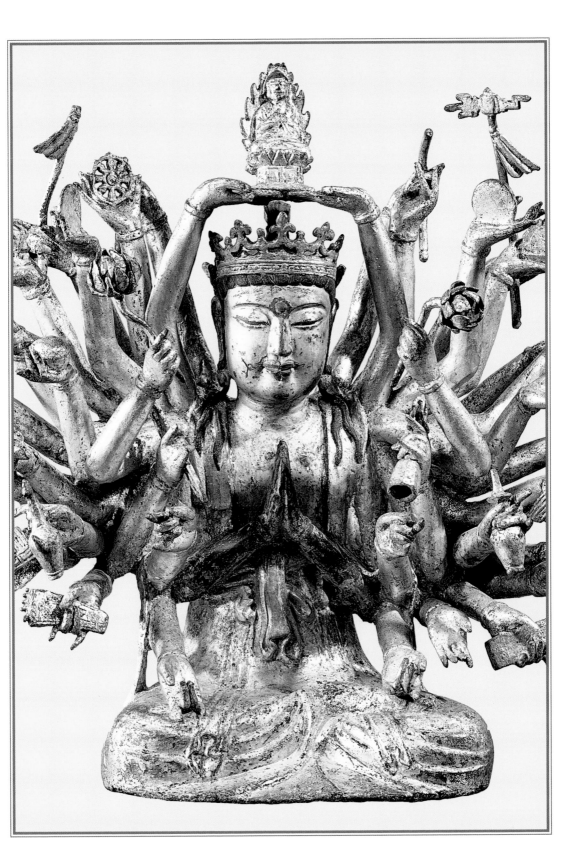

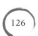

"That doesn't scare me"

Aizen-myoo is the god of passion and sexual attraction, which many people identify with love. Often seen as an obstacle to the spiritual path, love has become, according to Japanese esotericism, a force for good.

Here, we find a basic shift that is common to all Buddhism: ancestral beliefs are not rejected. Instead, they are transmuted.

The tendency for idolatry is transmuted to openness toward the unconditional. The cult devoted to trees and lakes becomes a way to celebrate a place conducive to the practice.

Or, as in this case, attachment becomes the ardent desire for enlightenment.

For those who are surprised to see Love represented in such unpleasant features, you should know that this is a way to show relentless subjugation, the power of love that avoids corruption and complacency. We find, in many alchemical texts in the West, similar descriptions where love possesses a frightening and terrible face, just like that of Aizen-myoo.

I especially like this face of wrathful love, because it feels more accurate to me than that of our chubby-faced cherubs. I think love looks like this face. It demands that we open up completely, get out of our comfort zone, take a risk, and overcome our fears and our petty concerns.

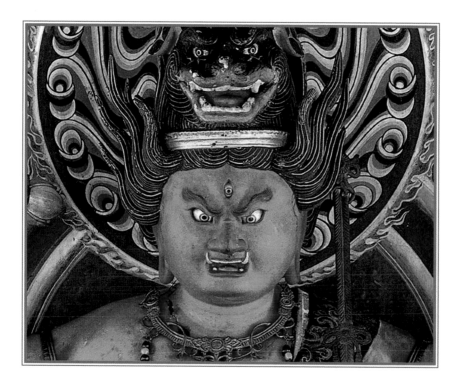

ABOVE AND RIGHT: *Painted and lacquered wood with crystal inlay, Japan, 14th–15th century*

The clarity of intelligence

Manjushri is one of the principal disciples of the Buddha and one of the great bodhisattvas. According to certain legends, he was born from a ray of light bursting out of Shakyamuni Buddha's forehead. The ray pierced a tree, out of which grew a lotus, and sitting in the center was Manjushri, adorned with silks and jewels.

"He whose beauty is charming" (his name literally means "gentle glory") represents prajna. This untranslatable Sanskrit word indicates clear intelligence, which must not be confused with knowledge that is conceptual, partial, and incomplete. Prajna is perfect intuition, the best intelligence, consummate knowledge, the ability of the mind to discriminate.

Manjushri, eternally young, is always represented as a peaceful adolescent. With nobility and gentleness, he sees reality as it is, fights ignorance, and favors spiritual knowledge. His skin is white and pure or sometimes a yellowy-orange color.

The intelligence he manifests cuts through confusion, the fear of seeing what is, the anxiety of learning. This is why Manjushri holds a flaming sword in his right hand. It's raised, ready to cut away all error and illusion, as in ignorance. Ignorance, in Buddhism, is understood as a true activity of the mind that refuses to see and chooses the dull comfort of confusion to the brilliance of truth. The intelligence of Enlightenment fights this, thus freeing the wisdom it suppresses.

True meditation is discernment. Through it, we transcend the idea of the self and the other. Through it, we understand the insubstantiality of beings and things. Through it, illusion dissipates on its own like a cloud in the summer sky. Through it, enlightenment is attained without anyone being enlightened, without anything being attained.

LANKAVATARA SUTRA

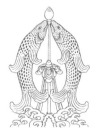

Mural painting, Ladakh, India

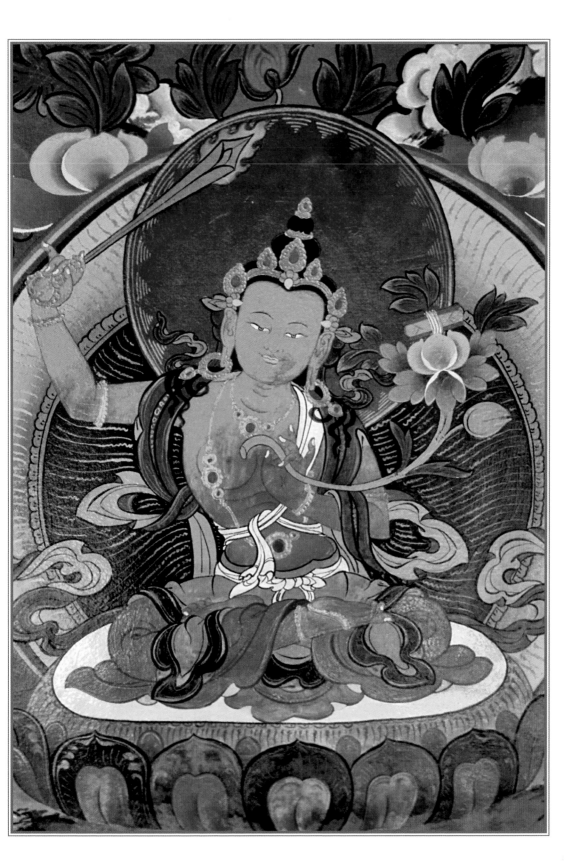

Meditation and action

Vajrapani is a hero blessed with great strength. He is sometimes represented in Greco-Buddhist art in a form similar to that of Hercules, holding a short vajra-shaped club (a vajra is a thunderbolt, or mythical weapon). He's known as the protector, "powerful as an elephant," who watched over Shakyamuni at his birth and also protected him from a landslide while he was teaching at Vulture Peak.

He manifests fierce determination and the absence of all hesitation in fighting confusion, cowardice, laziness, aggression, and foolishness.

He is the hero who removes obstacles, which is why he holds the vajra-thunderbolt. Like Thor's hammer, this weapon, which never misses its mark, returns to its owner's hand after completing its task. In this sense, it symbolizes the perfect action, which appears to happen automatically.

Sometimes we forget ourselves when we're absorbed in something we're doing: preparing a meal or writing a text, for example. When it's done, we feel we have only been present to allow the thing in question to take place. This experience is described in the texts as encountering Vajrapani. What counts here is not actually Vajrapani, but the experience to which it refers, and which is so deeply freeing. In other words, the important thing is this ability to act while completely forgetting ourselves in the joy of doing what we're doing. The action takes place as if it were automatic.

When I look at a representation of Vajrapani, it strikes me that, in Buddhist temples, we find serene Buddhas as well as crying Buddhas or angry Buddhas. Each one, as Jack Kornfield points out, "expresses the power and emotions after Enlightenment." Isn't this a profound lesson: all emotions, tended to with attentive presence and benevolent love, have their purpose.

Mogao caves, near Dunhuang, China, 8th–11th century

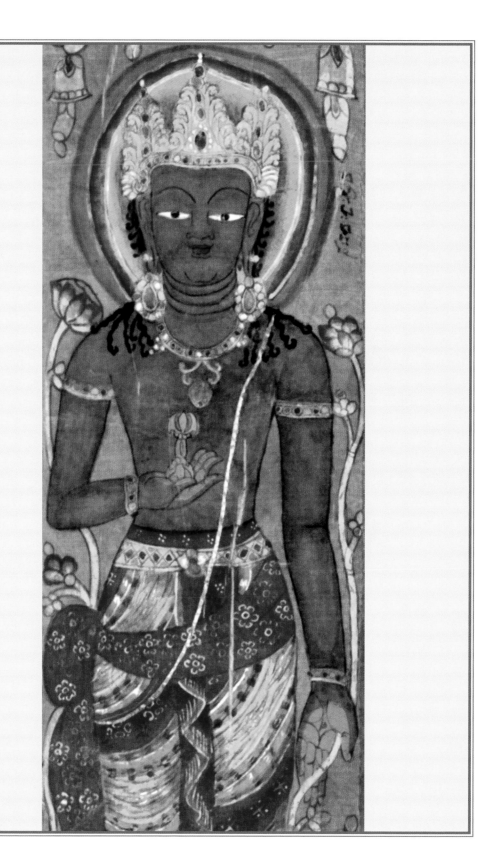

"The universally good"

Samantabhadra is the bodhisattva of universal goodness. He rides a white elephant with six tusks, symbol of strength and wisdom that conquers all obstacles. The six tusks demonstrate his victory over the attachment of the six senses (Buddhism considers the mind as the sixth sense). His emblems are the jewel that grants all wishes, the lotus, and the roll of parchment bearing his meditation sutra text.

He is especially worshipped in some Japanese Buddhist schools (Tendai, Shingon, and Nichiren) because he is thought to be the protector of the *Lotus Sutra*. This text, dating back to around the year 150 CE, affirms the universal dimension of the Buddha. His arrival as Shakyamuni is a skillful way of spreading the word to those of little faith, a way to lead them toward the spiritual path. But, in reality, the Buddha was never born, nor did he ever really live on earth. He is the love and presence that exists at the very heart of the present.

It's not by remembering his existence that we encounter the Buddha, but by practicing meditation. This is when we encounter his heart and mind—that is to say, the essential openness of his universal love.

Practicing the four immeasurables

Buddhist teaching's concern with becoming a remedy for the world can be summarized in the four practices.

First of all is benevolent love, which consists in wishing for everyone—including ourselves—to be completely happy, in the deepest sense of the term.

Next comes compassion, the intense yearning to free the world from all suffering.

To these practices, Buddhism adds joy in the face of happiness and the qualities of others. Rejoicing here consists of feeling deep in our hearts a sincere joy toward those who work for the benefit of others and whose benevolent projects are rewarded with success, toward those who have achieved their dreams with unceasing effort, and those with many talents. This joy is accompanied by wishing for their well-being and their qualities, rather than declining, to endure and grow. This is a transformative way to overcome jealousy and the tendency to belittle other people's deeds. In return, this practice gives us increased drive in pursuing our efforts.

Lastly comes impartiality. This wish for all beings to find happiness and to be relieved of their suffering should not depend on our personal attachments, nor on the way in which others treat us or behave toward us. Impartiality adopts the air of a caring and devoted doctor who rejoices when other people are in good health and concerns himself with healing all sicknesses, whatever they may be.

Yulin caves, China, 11th–13th century

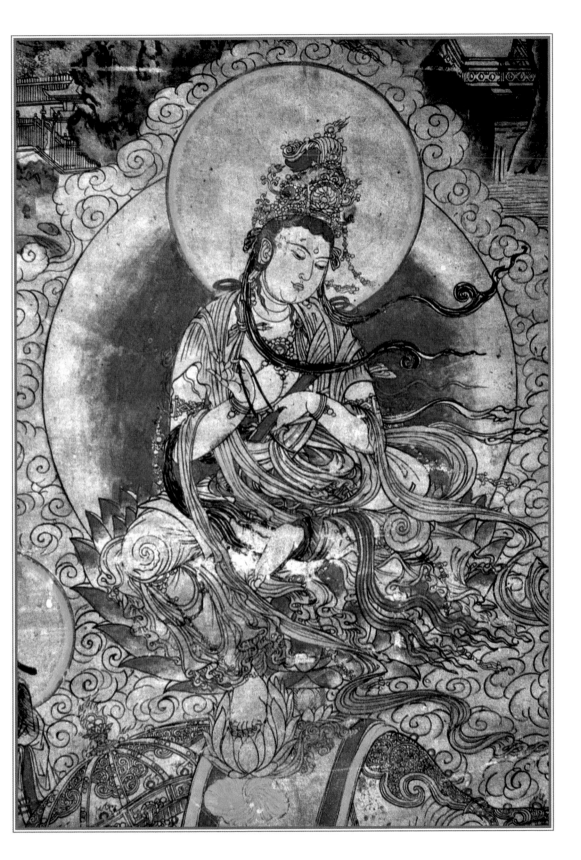

PART III

Encountering the Buddha within us

"Be your own refuge.
Be your own light."

BUDDHA

In this third part, I would like to help you encounter the original Buddha, who is none other than *the here and now*. In fact, for some Buddhist schools, the Buddha is not only the man who lived two and a half thousand years ago, but rather a state that each of us can get to know by meditating. The Buddha is then no longer considered as an example capable of enlightening those who follow in his footsteps: he is our own nature.

Admittedly, being preoccupied with our activities and our torments, we only occasionally experience this. But these moments do exist, especially in meditation practice. We feel a greater presence, a freeing detachment, and a simple and fresh breath of life. This is the Buddha.

Undoubtedly, he is sometimes hidden, like the sun when it's behind clouds, but, as with the sun, what conceals it doesn't alter its nature. It isn't because we don't feel the Buddha's presence in us that it's missing.

From the Buddhist perspective, meditation doesn't mean seeking a state of well-being or calmness, but opening our mind and our heart in a deliberate manner. Indeed, it is for this reason that I have persisted in the path of meditation. Practicing simply to calm my mind, watching my thoughts pass and returning to the present moment, would have seemed a little tedious in the long run. In contrast, knowing that behind my preoccupations and my commitments there is a wider, more open, and more loving dimension opens up infinite perspectives. This is, in my opinion, the great discovery of meditation practice; at least, it's the one that changed my life. It's difficult, of course, to talk about it. How do we, in fact, talk about this state of presence, of silence and benevolence, which eludes our usual way of communicating? It

seems to me that only poetry or certain works of art can succeed in expressing this profound experience. This is why I've chosen to show you images that attempt to describe this experience of openness and presence.

You therefore mustn't look for an actual person or character who once lived, even though he may have been someone extraordinary, but instead look for a state of your own being.

Why is discovering this pure presence so precious for our everyday lives? It's because this experience profoundly changes our relationship with confusion, with suffering, and with life's challenges. Even if this dimension may seem to be of a high spiritual standard, it's also very practical and can help us day to day. This may seem surprising, but it's true. Try it, and you'll see.

In truth, after having experienced this source of life, we can connect to our difficulties in a more confident manner. I am struck by the way in which Buddhism asks us to take on a profound change in perspective. Instead of considering our anger, our fears, our anxieties, our sadness, or our jealousy as problems needing to be eliminated or managed, it asks us to fully enter into a relationship with them, and put them to the test with steady and open attentiveness. Anger then ceases to be a fault, a bad thing, a mistake, or, conversely, something that is necessary. It becomes a certain form of presence, which, even if it sometimes turns sour, deserves to be explored and understood. This is how it can be transmuted. Meditation therefore helps us to transform our difficulties into possibilities, and our shadows into light. This very profound experience presents many similarities with the works of a number of psychotherapists.

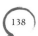

The original Buddha

Here, the original Buddha takes the form of a young prince in a blue color so intense that he seems to disappear into the sky. His nudity and his color symbolize the fundamental simplicity of primordial space. He is completely free of all obscuration and all impurity.

The original Buddha is the primordial unity which, depending on the school, is referred to as "emptiness," "natural mind," or "a way for things to be the way they are." Sometimes, by looking at length at the blue sky and getting lost in it, we feel a great sense of peace, and we forget ourselves: we encounter the original Buddha.

Here, the Buddha is in union with his consort. This is not to evoke a sexual act, as is sometimes thought, but to show the profound unity of all polarity. This image resembles the symbol of yin and yang. Indeed, just as yin and yang demonstrate a union bringing together contradictions, it lacks nothing.

We are no longer isolated, but in deep union with the world.

Attentiveness and presence: The secret of Buddhist meditation

> *Alas! The disciples of concentration, like cattle, practice stopping*
> *their thoughts and remain in the absence of discursivity,*
> *But what they call "natural state" is in reality only proud obstinacy.*
> *This is not the correct meaning of meditation.*
>
> LONGCHENPA, *The Natural Freedom of the Mind*

This quote by Longchenpa is illuminating. It shows us that we mustn't confuse mental calm with true freedom. Being like a silent animal does not constitute a great accomplishment. Meditation has absolutely nothing to do with the reality—referring back to two traditional images—of being as calm as a cow.

In practice, we cultivate a form of serene and open attentiveness. For example, we pay attention to our posture and our breath. In this way, we are more anchored to presence.

The crucial point consists in extending this attention as pure presence. We then pay attention to nothing specific; we're just there, fully.

> *When we return to the root, we find the meaning.*
> *When we get lost in the branches, we lose the true substance.*
>
> SOSAN GANCHI ZENJI

Painting on canvas, 19th century, Tibet

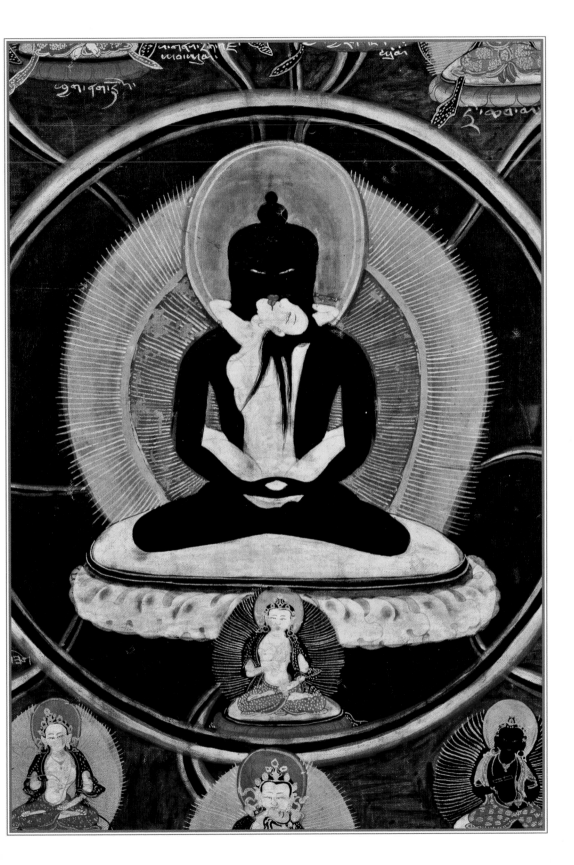

The primordial Buddha

This Buddha, named Vajradhara, is another manifestation of the primordial Buddha. He is presented with his hands crossed: one holding the vajra-thunderbolt, the other a bell. This is another way to show the completeness of the mind, which we discover when we practice meditation.

The vajra's origin is probably Mesopotamian. It symbolizes perfect action. As for the bell, it represents the intangible openness and the perfection of wisdom from which all things are manifested. The sound it produces is that of the teaching of the Buddha as proper, evocative, and creative speech.

Vajradhara brings together perfect action and the most complete openness.

Notice that he has the face of a young sixteen-year-old adolescent, that his manners are highly noble and his grace almost feminine. His youth shows us that the presence we discover by practicing is youthful. Buddhism doesn't in the least believe that wisdom requires extensive experience and a long beard. It's about being free and spontaneous, open and curious.

Personally, I have often had the impression that meditation practice in fact puts me in touch with a youthful and joyous source.

Meditation on primordial openness

From time to time, analyze your mind;
Assure yourself that it is not a tangible thing,
That it lacks a center and a rim.
Then let this discovery
Take on all its fullness.

From time to time, blend your mind with the immaculate sky;
Raise it, extend it,
And leave it wide open,
Like a space that is both vast and omnipresent.

SHRÎ SIMHA

These two verses are totally revealing of the simple yet profound instructions of Buddhism. It suggests two ways of finding the original or primordial Buddha—the reality that exists beyond the small idea that we have of ourselves.

The first one asks us to use the intellect in order to abandon the intellect. We examine our mind, which we try to understand, and we discover that it's impossible. The mind is not a thing. While we can see the blue of the sky, taste the fresh water from a spring, or feel the temperature through all the pores of our skin, we cannot touch our mind, which is unseizable. The second one asks us to dissolve our mind in open space—in, for example, the vastness of the sky.

▶

Thangka, Tibet

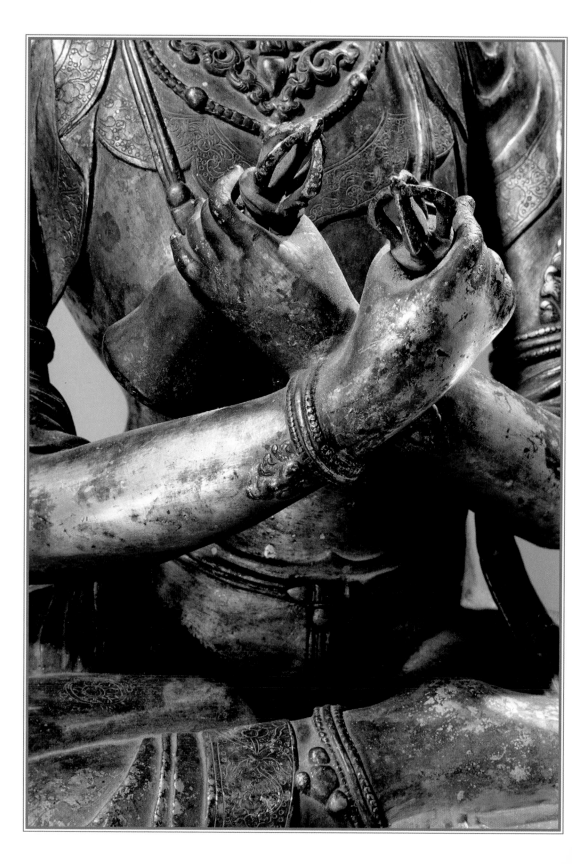

These instructions are, in a way, so simple that we struggle to understand them. They certainly left me perplexed for a long time. We need to be patient. The lessons gradually become clearer as your practice deepens. No one learns to read or to ride a horse in a day! As for the great artists, don't they often say they never stop learning? It's the same for meditation. It develops over the years.

ABOVE: *Stupa, Sanchi, India, 2nd century* B.C.E.
LEFT: *Bronze, Tibetan art, 17th century*

Deity in union

These images presenting the original unity of the meditative presence come from Tantra, which, in the West, is often identified with sexual practices. In reality, Tantra means the Buddhist path that aims to bring out the wisdom at the heart of all things and to overcome the common dualist attitude which *rejects* all that is dirty, impure, and confused instead of *transforming* it. It is as if Tantra radicalizes the Buddha's gesture of compassion, which aims to cure everything.

According to this approach, Enlightenment is the union of wisdom as pure vision and warm and intense compassion. The male deities embody this compassion and, through this, all action, while the female deities manifest the openness of wisdom, where all phenomena can emerge and dissolve.

Without the openness of emptiness, compassion would simply become an egocentric enterprise—an effort to help someone who, because of their wretchedness, appears inferior to us. Wisdom without compassion would be hollow and therefore vain.

SOME KEY NOTIONS OF THE BUDDHIST TRADITION

Impermanence (or the free movement of phenomena)

This is one of the most widespread ideas of Buddhism today in the West: nothing is permanent as everything is subject to change. Time passes and nothing endures. All people know and experience this. But still we continue trying to secure and hold on to things, making us unhappy. Buddhism asks us to be more flexible and to try not to be rigid or prevent situations from changing.

The main mistake would be in thinking this idea is a theory on reality, like the theory of relativity in physics. What the Buddha's teaching highlights is not the physical laws of the production of things, but our way of wanting the things to which we're attached to endure eternally. Impermanence, which is this freedom specific to reality, mocks our tendency to want to hold on to everything. It is in fact about recognizing that reality eludes all control.

Discovering impermanence is not like discovering a philosophical theory, but experiencing the profound freedom demonstrated by the ultimate Buddha in his own way. The Buddha, as open space, is a sign of the "free movement of phenomena."

Thangka, Paro, Bhutan, 20th century

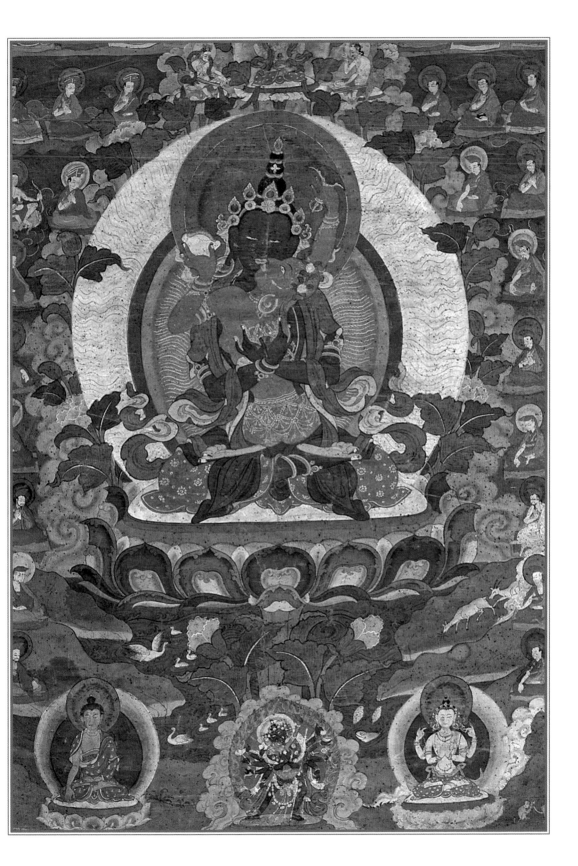

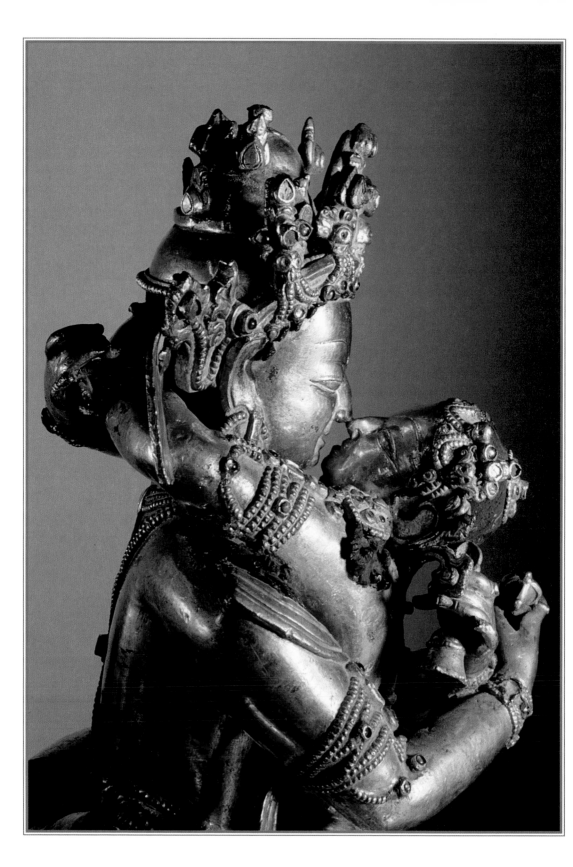

Interdependence (or the discovery of relational reality)

We often think that we are isolated beings who must choose to make an effort to connect to other people or things in the world. In reality, we're already connected. Things have an effect on us, and what we do changes the course of things.

The aim of this teaching is to free us. Being aware that everything is connected, and that all our actions are a commitment, delivers a profound openness. We are already of the world and not an isolated island. This comes back, as does Buddhism, to not seeing selfishness as a moral fault but as an error of judgment.

Personally, I don't find the translation from Sanskrit of pratityasamudpada *as "interdependence" satisfactory. The notion of dependence is so restrictive that, in my opinion, it creates confusion when it's taught. Instead of thinking of all things as being dependent on each other, shouldn't we think of them as co-belonging to each other in a bond that is "inter-being" or simply relational?*

Emptiness

Emptiness is also one of the key notions of the Buddhist tradition. Badly misunderstood, it also leads to profound misinterpretation. Let's try to look at this more clearly.

Buddhism doesn't say that nothing exists; it emphasizes the difference between reality—intangible and changing—and the constructs with which we mask this, to the point of mixing them up. Things are free of our conceptions about them: our ideas never, in fact, say everything about anything.

Nagarjuna, an Indian Buddhist monk who lived seven or eight centuries after the Buddha, was the first to give a coherent presentation on the subject. Using reasoned demonstrations, he showed that our assertions on reality suspend it and lead us astray.

"To speak of existence is a view of permanence, to speak of nonexistence is a view of annihilation. This is why the sages do not remain in existence or nonexistence," he therefore specifies. This is emptiness: the negation of all points of view, the destruction of all propositions, with no other support than that of openness to the phenomena freely recognized.

Buddhism asks us not to depend on concepts, however scholarly they may be, but to make the leap into openness. This is worth repeating: emptiness is not a theoretical concept on reality, but the experience of a decisive openness.

◆

Bronze and precious stones, Tibet, 18th century

The Buddhas of the five wisdoms

There are many ways to show how meditation can help us become more fully human. We could first of all emphasize the precision and attentiveness that bring us to the here and now. We could also evoke the primordial mind that, like the sky, is always present. But it's equally possible to experience the five qualities the practice allows us to discover. This is the role of the Buddhas of the five wisdoms, who make up the various directions of a mandala.

Each Buddha is associated to an emotion, one of the five colors (white, blue, yellow, red, and green), one of the five elements (space, water, earth, fire, and air), a landscape, and one of the five directions.

When we are prisoners of illusion and suffering, we see the world as filled with objects of desire, hate, jealousy, indifference, or scorn. We no longer perceive the perfect beauty of the universe embodied by the five Buddhas. To meditate is to retrieve these qualities we've forgotten or lost by entering thus into a mandala.

AREN'T ALL THESE REPRESENTATIONS OF GOD?

The life of the Buddha tells us a story of a man who, just like each one of us, was once lost before turning gradually toward the true source of life. Of course, certain aspects of his legend give a different depth to the story, but, first and foremost, it is a path we can understand and follow.

But, then, why has the Buddhist tradition given rise to so many different representations of the Buddha? This phenomenon may indeed seem surprising. Aren't all these images of gods? Hasn't Buddhism—which is a profoundly nontheistic tradition, independent of whether or not you believe in one or more gods—renounced itself by having these? What exactly are all these representations about?

In truth, these representations are ways to teach us how to fully enter into love, compassion, or unconditional openness toward the heart of the present. These are, in a way, instructions on meditation.

We should understand that there's no contradiction between their existence and the nontheistic aspect of Buddhism. Rather than presenting us with a treatise—and, indeed, there are some very profound ones—these images embody the deep meaning of the teaching.

As observed by Bokar Rinpoche, these figures "are not, in essence, superior individuals living in far-off worlds and occasionally arriving to rescue us beings, even if, from the perspective of their manifestation, they may appear as such." True divinity is the nature of our own being. It doesn't reside anywhere other than in our own heart, here and now.

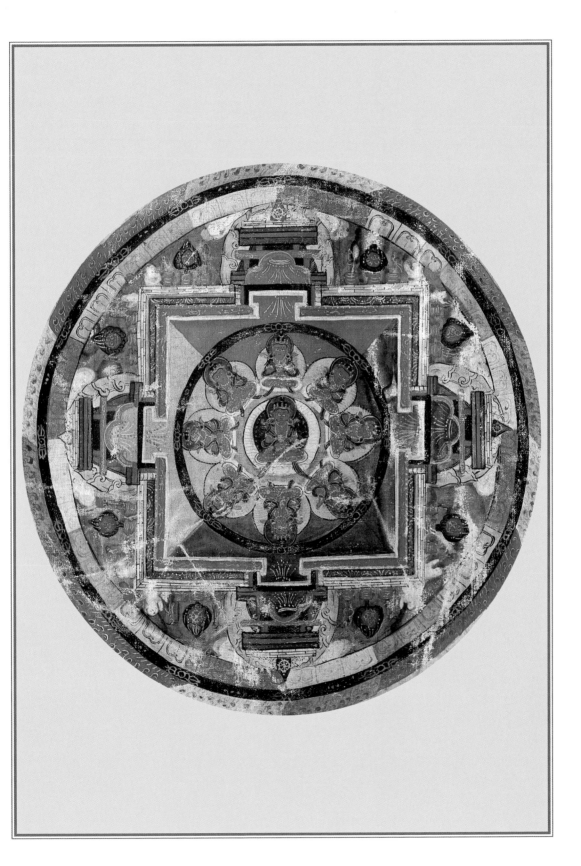

Overcoming duality and ignorance (The Buddha in the Center)

Vairochana is the Buddha who guards the center of space and welcomes all. His hands make the gesture called "the wheel of Law," with the right hand on top of the left, fingers extended and touching. This gesture signifies the setting in motion of the wheel of Law and the spreading of Buddhist teaching.

His iconography, which differs from that of the other Buddhas, is closer to the Persian deities such as Zoroaster. Like him, he's compared to the sun.

So what experience does this refer to? To those moments when we're able to accommodate everything. There may be noise, or something that irritates us, but this doesn't make us react. We are aware of it, but in a relaxed manner.

Buddhist meditation is not like the mental gymnastics required to put you in a state of relaxation. It's quite a different attitude because it's without any particular objective, without an immediate requirement to succeed. It's more about being open.

CHÖGYAM TRUNGPA

LOOKING FOR THE NONEGO

What is a Buddha? It's the experience of the nonego. Every image of the Buddha aims to show us a state of presence, of love, and of endless trust. But what, then, is the ego? It's the set of mechanisms and habits that makes us forget this experience. Strangely enough, in the West, the word is used in a sense that no longer has much to do with that of Buddhist teaching. In the Buddhist tradition, the ego, which we're supposed to abandon, destroy, or manage, doesn't exist. The ego is more like a process of rigidity and control, which never succeeds in achieving its plan. We cannot succeed in controlling everything. Life doesn't stop springing up. This battle to control life is exhausting and pushes us deeper into suffering.

In other words, the ego creates a barrier between "me" and "this," which could be a thing or a being.

The path consists of destroying this barrier.

I'm amazed by the havoc this notion creates, especially among people committed to Buddhism. Instead of allowing them to discover that the truth about their being doesn't reside in their fears, anxieties, and attachments, and that there is instead a much wider openness within them, it provokes profound guilt.

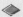

Wood sculpture, Japan, 12th century

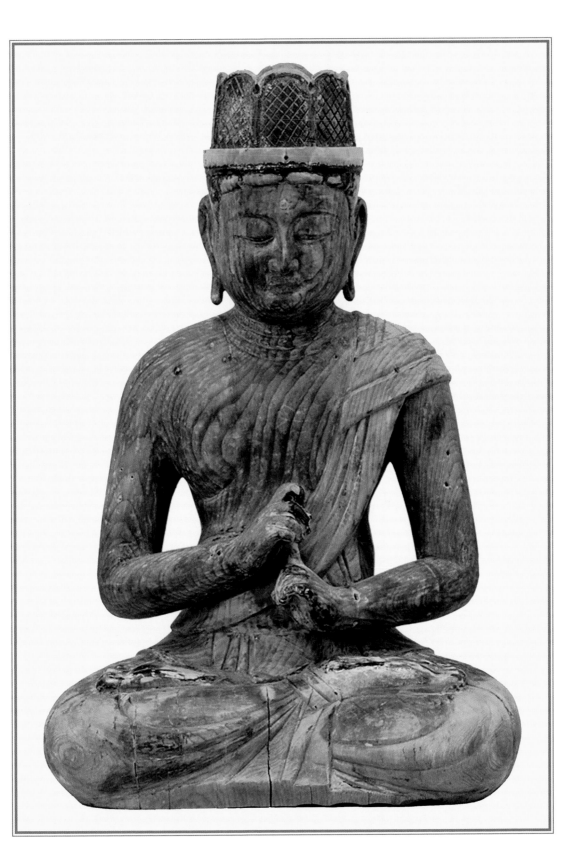

The Buddha of the vast mind (The Buddha of the East)

Akshobhya means "the Immovable" or "the Unwavering." He guards the direction of the East and is linked to the water element. He symbolizes a mirrorlike wisdom, able to reflect things as they really are down to the smallest detail.

At Borobudur, in Indonesia, he's recognizable from the gesture of his right hand resting with his palm facing inward on the right knee and his fingertips touching the ground. His left hand holds a vajra with five sharp points, symbolizing the indestructibility of pure conscience. He is sometimes depicted in the color blue. The Buddhas of Borobudur used to be covered with a colored coating, probably in fairly bright shades, but, as in our cathedrals or the ancient Greek temples, the sculptures have now faded to the color of bare stone. It's possible that they, too, were once colored a bright blue.

Meditations on the clarity of the mind
The Buddhist tradition has given rise to numerous masters who, through their spiritual awakening, have known how to communicate the original meaning of all presence and the source of our own humanity in a direct and vivid manner. I have gathered together some of their instructions here:

When we speak of "clarity," we are referring to that state which is free of sloth and dullness. This clarity, inseparable from pure energy, shines forth unobstructed. It is a mistake to equate clarity with awareness of thoughts and the colors and shapes of external phenomena.

JIGME LINGPA

Mind's nature is, and always has been, Buddha. It has neither birth nor cessation, like space. When you realize the real meaning of the equal nature of all things, to remain in that state without searching is meditation.

GARAB DORJÉ

There, now, look! Look inside.
Look into your own mind.
If you look into your mind, you will see nothing,
Because it is not a thing.

KARMA CHAGMÉ

Borobudur Temple, Java, Indonesia, 18th century

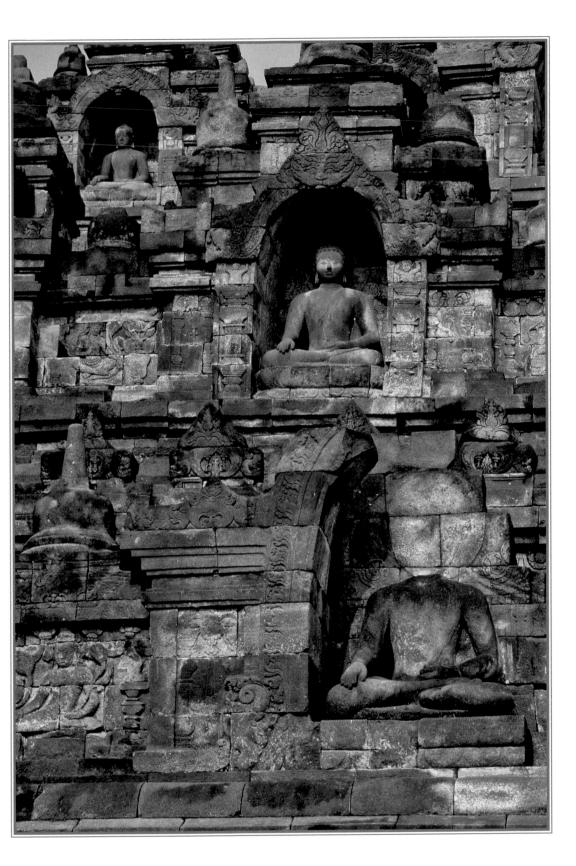

The Buddha of giving
(The Buddha of the South)

Ratnasambhava, meaning "Origin of Jewels," is depicted with his right palm facing outward, in the gesture of giving, and his left hand usually holding a jewel. This jewel that grants all wishes is an image of the enlightened mind in which all qualities are complete, leaving us fully satisfied. Ratnasambhava is the lord of generosity and equanimity.

When man fails to recognize him, he searches for him and becomes greedy, always concerned with possessing more things. But this quest distances him even more from Ratnasambhava, who appears only to he who relaxes in the very profusion of Enlightenment.

Ratnasambhava is associated with the South and the element of earth—he welcomes all and possesses resources long seen as inexhaustible to man.

ABOVE: *Stupa, Sanchi, India, 2nd century* B.C.E.
RIGHT: *Shalu Monastery, Tibet, 14th century*

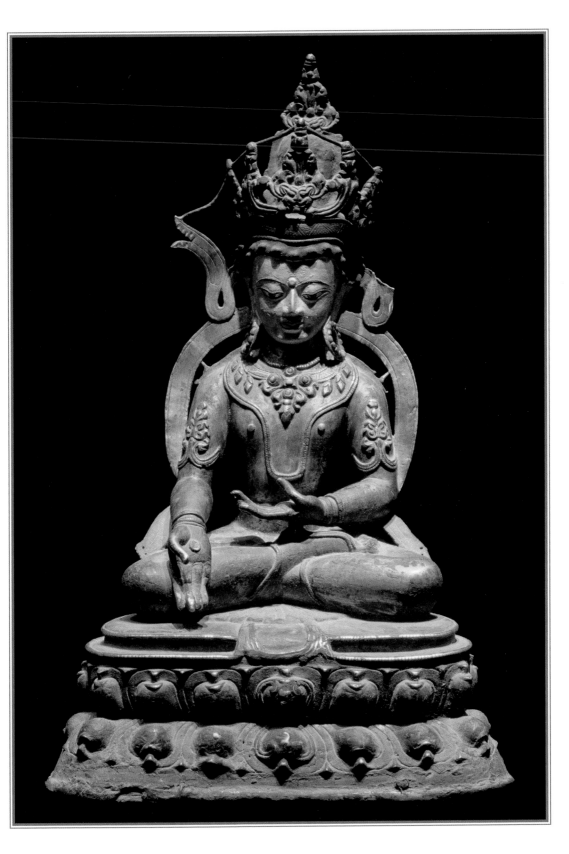

The Buddha of great compassion (The Buddha of the West)

Amitabha is the Buddha of "infinite light"; he lights up the entire universe. His light is boundless, illuminating all the worlds of the ten directions. His element is fire, captivating and magnetizing.

The Buddha of the West, he sits in the gesture of meditation, with his hands facing outward, toward the sky, and his thumbs touching. This gesture symbolizes the authentic state of peace, and is used when resting by those who practice meditation.

Amitabha is usually seated at the center of a lotus flower or on a throne decorated with peacocks, which—according to Indian mythology—eat fish, giving their feathers their magnificent color. Like this animal, Amitabha transmutes chaotic passion into compassion, and attachment into altruistic fervor.

ABOVE: *Stupa, Sanchi, India, 2nd century* B.C.E.
RIGHT: *Japan, 18th century*

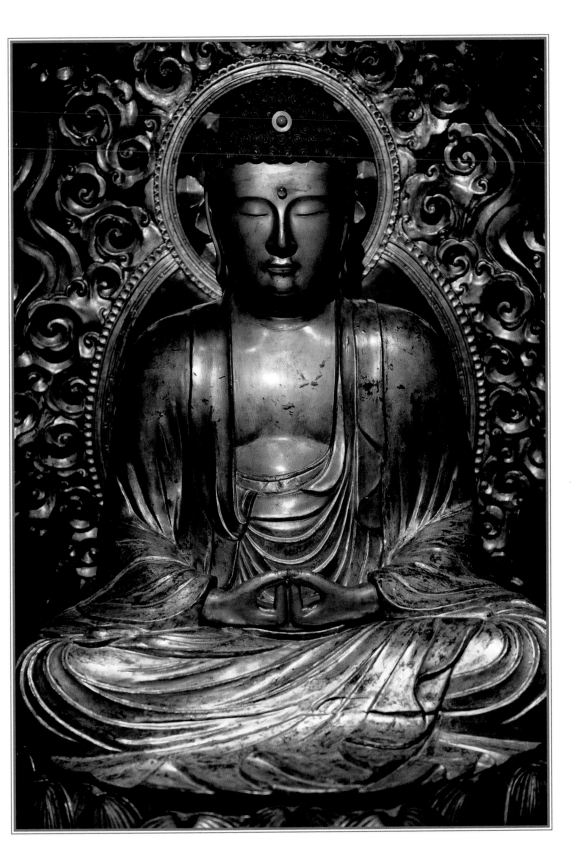

The Buddha of perfect action (The Buddha of the North)

Amoghasiddhi, "one whose accomplishment is not in vain," is the Buddha of action. He is associated with the element of air, wind, and mobility. His palm faces outward, at chest height, in a gesture showing protection and fearlessness. Nothing can harm the person who has reached Enlightenment.

He is therefore the Buddha of pure action, indestructible and perfect. This type of action is always completely in keeping with the situation in which it takes place and not the result of the neurotic unraveling of personal ambition.

Amoghasiddhi is colored green, and his throne is sometimes supported by mythical birds (*garuda*), the symbols of enlightened activity.

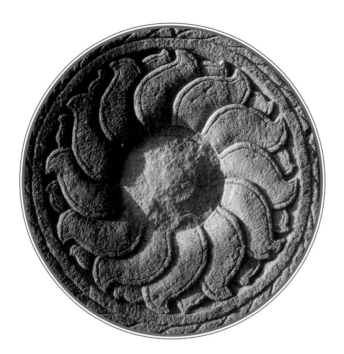

ABOVE: *Stupa, Sanchi, India, 2nd century* B.C.E.
RIGHT: *Western Tibet, 14th–15th century*

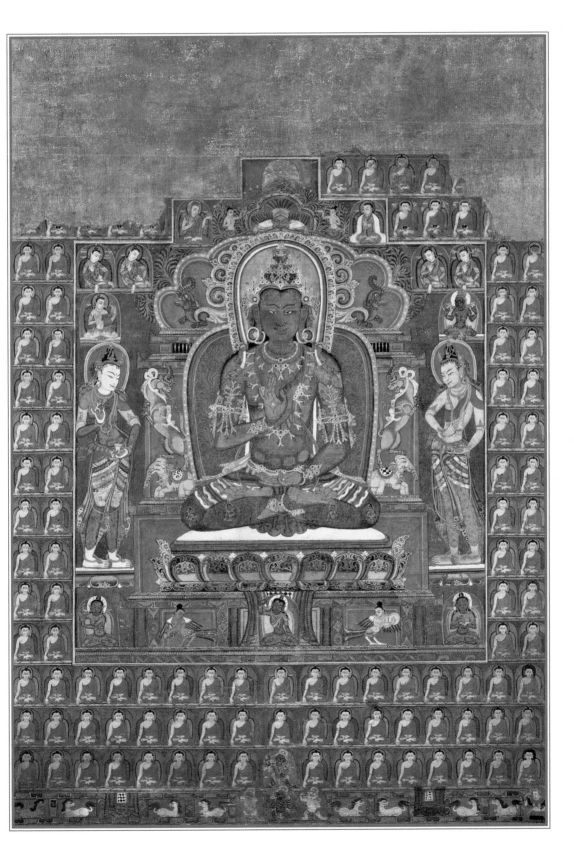

Conquering death

Yama, in Indian mythology, is the god of death. While he was decimating the population of Tibet, the people invoked the bodhisattva of pure intelligence, Manjushri, who defeated him and made him the protector of the Buddha's teaching.

Yamantaka—or the Conqueror of Death—therefore became the wrathful expression of Manjushri. Why? Because he defeats ignorance, which prevents us from recognizing the richness of life.

Conquering death, from this perspective, is to succeed in overcoming selfishness.

Yamantaka has the head of a wild bull with three eyes and sits on a buffalo. In his right hand he triumphantly brandishes a trident with a skull, by way of a scepter, while in his left hand he holds a rope, to capture the demons who represent our selfish and painful emotions.

BUDDHISM AND DEATH

Buddhism has devoted much thought to the meaning of death and is acknowledged for its development in Asia of benevolent support for the dying.

In Buddhism, death is always present within us. It's due to ignorance that we believe it to be the end of our life. In actual fact, we are called upon at every moment to die; every day of our lives, we're required to abandon certain things.

Meditation practice is a tremendous preparation for death, because it teaches us to connect with what is, moment by moment, and not to get stuck in the past. It demonstrates to us the necessity of letting go of all our attachments. Following this path is to connect to the possibility of death, to think about it and prepare for it. From the Buddhist perspective, when someone is sick or close to dying, it is preferable to tell them, to allow them to prepare for it.

Painting on tower facing the Potala Palace, Lhasa, Tibet, 21st century

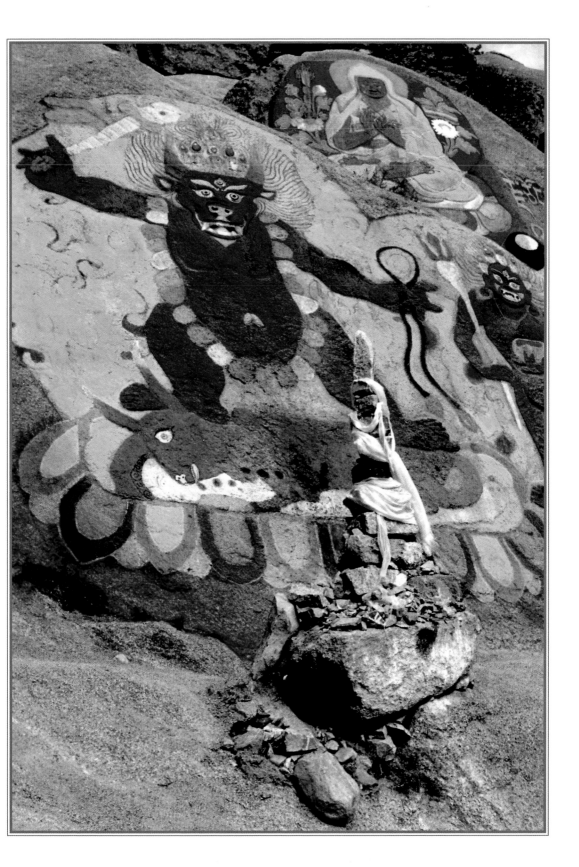

The spirit of protection

The frightening aspect of this deity has long led many Westerners to consider him a demonic being. But he's nothing of the sort: on the contrary, his fierce aspect is a sign of his effectiveness in protecting those who practice against the hostile powers of confusion, cowardice, or fear.

When we practice, we settle down and discover a simple way of just being. We also learn to open up our heart. Sometimes, we find ourselves attacked by confusion, fear, and bursts of anger or intense desire. It's at this precise moment that the spirit of protection can emerge. It is this gesture that cuts through confusion and preserves openness in its incomparable tenderness.

This is what Mahakala is like. He is surrounded by flames, representing the continuous spreading of his energy, devoid of even the smallest amount of aggression and always compassionate. The tiara of skulls he wears symbolizes the negativity of emotions. Far from destroying them, abandoning them, or condemning them as being bad, Mahakala wears them as adornment.

We, too, should try to wear our confusion like a tiara, rather than wishing it would disappear and then suffering when that doesn't happen. An attitude like this—which is infinitely more constructive—is consistent with the great principles of the martial arts: relying on the energy of the adversary to destabilize and conquer him, rather than fighting him with another force.

Our presence, the appropriateness of our action, and the gentleness of our heart will, in fact, return the aggression back to itself, not allowing it to take hold. This is one of the teachings of this painting.

Sikkim, India, 20th century

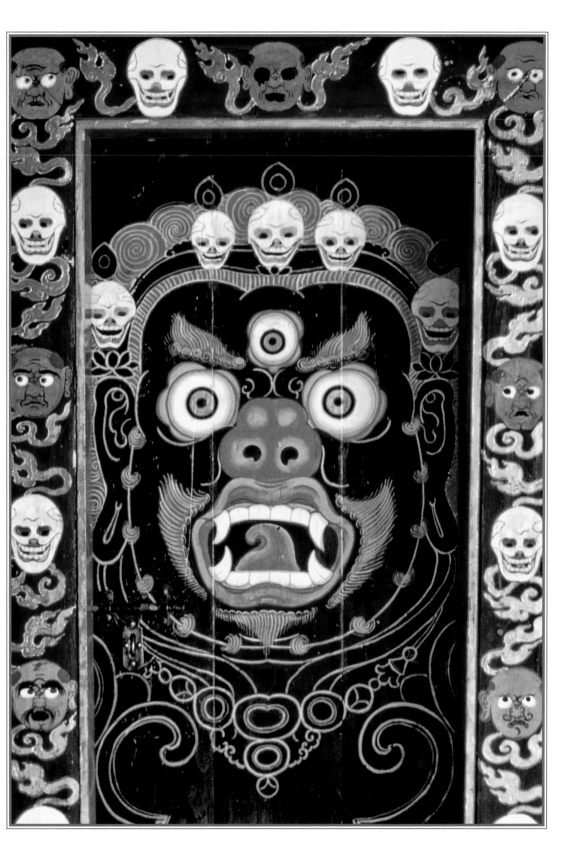

The Buddha of medicine

The Buddha has often been compared to a physician who must diagnose an illness by searching for the cause and then prescribing the remedy to heal the patient.

Thus, the Buddha sometimes takes the form of "master of remedies." He is therefore the one who heals the ills of the body like those of the mind. In this role, he's usually represented in a luminous and translucent blue color, wearing a red robe decorated with gold floral ornaments. The palms of his hands are also red.

In his left hand, he holds a cup filled with medicinal plants and fruit. He often has a pointed protuberance on his skull, while that of Gautama Buddha is wide and flat.

The two people at his side are the two bodhisattvas of sunlight and moonlight. They watch over all men during the day and the night.

Traditionally, the master of remedies is depicted sitting on top of seven figures, who are the emanations of his activity. They have each created a medicinal plant.

Meditation on illness

It is a good thing not to experience illness as an unjust attack that we can only confront with our anger.

Here, the teaching gives you several directions. First of all, you could see if your illness is due to an imbalance in your life. If so, it asks you to find the harmony you have lost. You could also tell yourself that this difficulty constitutes an opportunity to progress along the Way. You would then need to overcome impatience and discouragement, and keep the jewel of benevolent love in your heart.

The illness also allows you to develop compassion for all beings. Indeed, whenever we suffer, we are more able to turn our mind toward those who, like us, are experiencing great turmoil.

Thangka, 12th–13th century

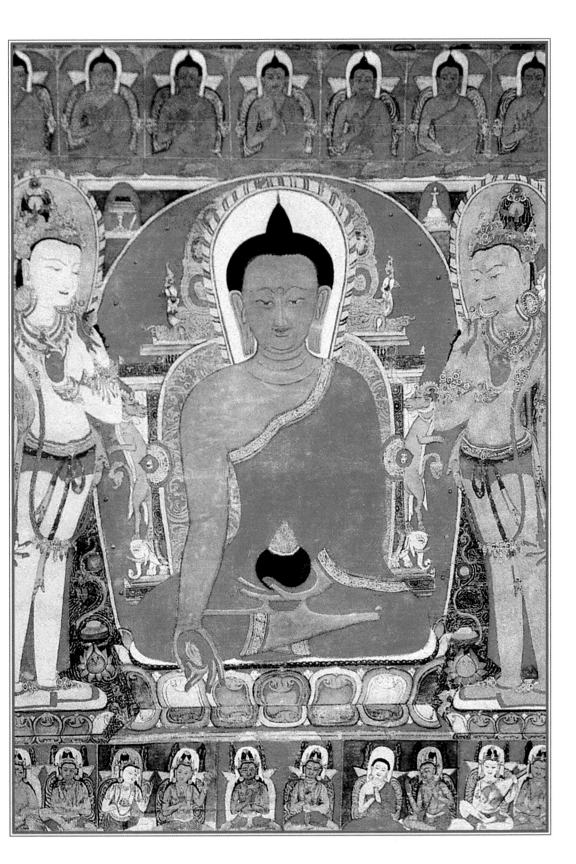

PART IV

A teaching that lives on

"He who teaches holds the same rank as that of a father."

LAO SHE

In the first three parts, I introduced the Buddhist path: the path to freedom, the path of benevolent love and compassion, and the path toward an open mind. But how do we actually engage in this path, faced with challenges both in our lives and in the world? How can the practice of morality that the Buddha presented over two and a half thousand years ago be applied in today's world? How can we rethink this teaching to keep it relevant? What can Buddhism teach us today? What paths can it open for us? And what can each of us learn from this?

I have chosen to reply to all these questions in this fourth and final part, by presenting you with the lessons from some of the greatest masters of Buddhist history. As you discover them, you may be just as surprised by their creative ability as I was. None of them were content with simply following the instructions to the letter. Each of them chose to rethink these, depending on the context in which they found themselves. As a result, they were true to the Buddha's famous parable:

A well-constructed raft was built.
Having crossed and arrived at the other shore,
I have mastered the river.
I no longer need this raft.

Buddhist teaching is a raft that allows you to cross the river.

It's not a question of worshipping the raft, but of continuing on your path. What counts isn't the faith in a doctrine, but the transformation it creates within us. The incredible malleability of Buddhism explains how these masters have always found new ways to experience and communicate its lessons.

I have gathered together here some of their great lessons for you to discover: the connection between study and meditation, meditation and daily life, the importance of not reducing the practice to a mere technique but actually living the experience, and the way that Buddhism helps us to transform the world.

The dialogue with Confucianism and Taoism

This image illustrates the arrival of Buddhism in China—without doubt, the most important moment in the history of the spreading of this tradition.

Here we see Lao-Tzu, author of the famous *Tao Te Ching* (literally, "The Book about the Way and Virtue"), written when Taoism began, and Confucius, considered to be China's first educator (his thinking was concerned with how men could live in harmony with each other, giving birth to an astute political concept). The image shows them welcoming the newcomer; in reality, this silk welcome wasn't quite so straightforward.

How did this tradition arriving from India—a civilization so far from China—establish itself there? Even the monasticism encouraged by Buddhism is contrary to the spirit of Confucianism, which emphasizes filial devotion and the necessity to perpetuate the family line. In addition, Buddhism doesn't encourage participation in the common prosperity through work and service to the empire. It was also fought off for a long time as being a foreign practice. So how did the Taoist quest for immortality finally come together with the Buddhist quest for the abandonment of the present?

In fact, it took several centuries for this tradition to successfully establish itself so deeply in China.

Gradually, these three traditions began to influence each other to such a level that, today, it's difficult to distinguish between the original ideas of each branch.

What is the great lesson for us on this introduction into China?
In this image, the bearers of the great Chinese traditions welcome Buddhism, represented as a small child.

But what about here at home? Which of the great masters would have been able to welcome Buddhism? Could we imagine Socrates, founder of Western philosophy, and Orpheus, legendary teacher of poetry, taking the Buddha into their arms?

In order to establish itself in this new country, Buddhism had to enter into a dialogue with existing traditions. This is precisely what's at stake today, for people like me who are trying to teach the Buddhist tradition. It has to be done by attempting to identify which sicknesses of our era need to be helped and healed. Simply repeating the Buddhist doctrine by behaving as if the Western world of the twenty-first century were similar to China or Tibet in the nineteenth would guarantee us losing our way. Our challenges are not the same. Naturally, we could think about the threats the earth currently faces and the tyranny of profitability. Our advantages aren't the same, either. We also need to take into account democracy, and the place that women at last have in society, still the subject of gross injustice in Asia. This is why I often work with philosophers in the Western School of Meditation, to help us understand the spirit of our own times.

Silk painting, China, 18th century

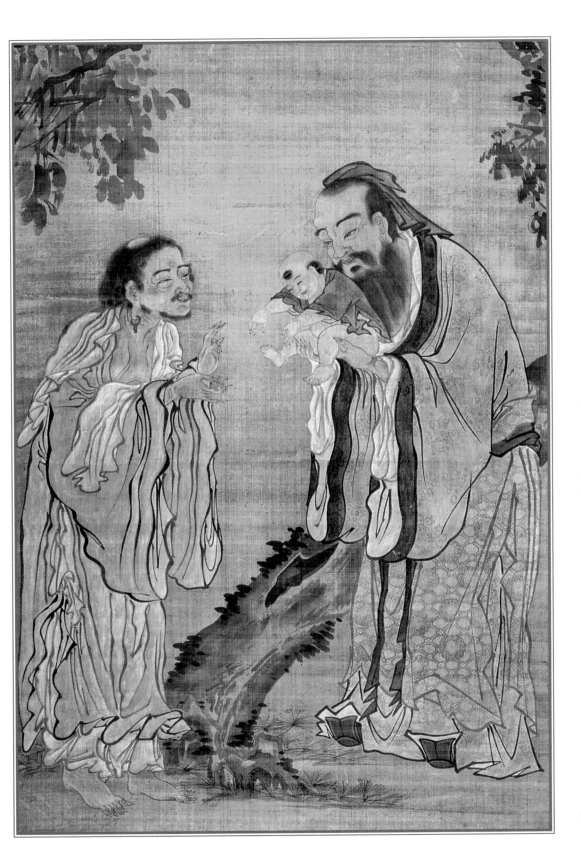

Heart-to-heart communication

The Indian monk Bodhidharma is believed to have introduced Chan Buddhism—which focuses on meditation practice—into China in around the fifth century. He himself remained in meditation for nine years.

While he was practicing alone, a Chinese monk named Huike came to ask for his teaching. Bodhidharma pretended not to see him. In desperation, the monk cut off his own left arm and presented it, covered in blood, to his master.

"My mind is not yet at peace. I beg of you, Master, please pacify it."

"Bring me your mind and I will pacify it," replied Bodhidharma.

"I have searched for my mind but I cannot find it."

And so he was pacified.

Bodhidharma disapproved of idle talk, which can overwhelm people and separate them from their being. This explains his enigmatic and brash replies, and why he is so often represented as being irritable and fierce, with bushy eyebrows. Determined to abandon the preoccupation with complex speculation specific to Indian Buddhism, Bodhidharma succeeded in establishing a distinctively Chinese form of Buddhism.

Chan philosophy spread to Japan, where it was called Zen. Bodhidharma's name became Daruma. Chinese ink painting is typical of the Zen spirit, where perfecting calligraphy is seen as a celebration of the spirit of Enlightenment.

What is Bodhidharma's great legacy?

It is important to believe that meditation opens up the way to deep transformation, and can help us—in a very practical way—to suffer less and be more courageous and open. But this should not make us miss out on the essential fact that meditation is, first and foremost, the proof of our deepest humanity.

It's through the communication of one mind with another, or of one heart with another, that such a conviction can arise. We then no longer depend on the quality of our experiences—peaceful or warm, for example—which constantly changes. We discover a stability that is unchanging: presence and benevolence.

Having organized gatherings of several hundreds of people to practice together, I recognize the importance of those moments when everyone has the impression of experiencing a communion.

Japanese Kakemono, 16th century

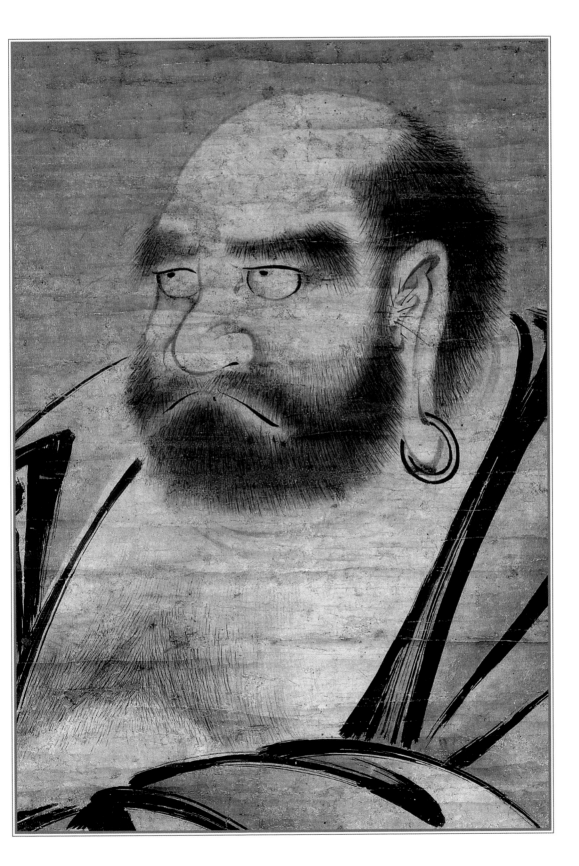

Confronting the difficulties of our times

In the eighth century, King Trisong Detsen invited the Indian master Padmasambhava to come to Tibet and pass on the Buddha's teaching. However, this sage wasn't welcomed with open arms. The spirits of the country refused his coming to their land, and the clergy of the native religions were opposed to him. Padmasambhava, like all the great pioneers, understood that he would not be able to communicate the Way of the Buddha without deeply connecting to the history and the political and spiritual situation of Tibet. Instead of simply repeating the doctrine as he had learned it in India, he tried instead to discover what it could offer in response to the state of affairs there. In this sense, we could say that he invented a Buddhism, which, while being completely faithful to the Buddha's teaching, could establish itself in the Land of Snows.

Because Padmasambhava loved Tibet with all his heart, he could understand it and transmute whatever was detrimental to its development. For this extraordinary heroism, which pierced through their superstitious materialism, the Tibetans named him Guru Rinpoche, the "precious master." Since then, they think of him as a second Buddha.

How can Padmasambhava be an inspiration to us today?
The Tibetans, rather than remarking that Padmasambhava attacked their superstitions, their sectarian nationalistic character, and their bloody sacrifices, instead say that he conquered the demons. These are two ways of referring to the same thing.

And what about us—what are our demons? I believe they are consumerism and the tyranny of profitability. Thanks to these, it's very difficult to follow the direction of the Way. It would be necessary not only for meditation to be efficient, but for this efficiency to be proven, measured, and integrated into reproducible protocols. For many people there's no problem there; it's a good way to be able to spread the practice.

This is a grave illusion and contrary to the spirit of the practice. People, moved by greed and selfishness, could indeed absolutely practice meditation with the aim of being more efficient, to better exploit people and destroy the earth.

The issue is not to know whether meditation is spreading, but what results it is producing.

Padmasambhava succeeded in planting the banner of dharma without making any compromises. This is why he's so inspiring for our times. And it isn't by chance that numerous masters who played an important role in the spreading of Buddhism in the West have looked to him.

Padmasambhava is the manifestation of the fearlessness that fully engages with the suffering and confusion of his time in order to free what is possible. He shows us that meditating implies fully connecting with the difficulties of our present time.

Bhutan, 20th century

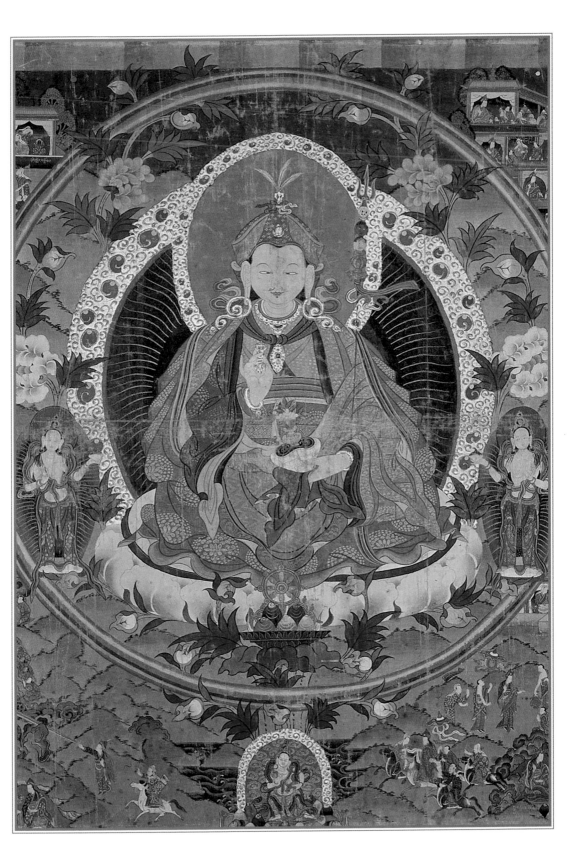

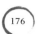

How to overcome your errors

In Tibet, Milarepa is one of the most famous figures of Buddhism. He is the first Tibetan to have attained Enlightenment without making the voyage to India, thus proving that dharma, from then on, was established in the Land of Snows.

In his childhood, his uncle dispossessed him of his wealth. He, his mother, and his sister were then reduced to the state of servants. His mother pushed him to take revenge. By using sorcery, he caused the death of his relatives. Consumed with guilt, he then committed himself to the Way. He spent the major part of his life in solitary retreat in various hermitages and caves or at the top of mountains, conversing with animals.

He is known for the numerous songs that he composed spontaneously. Abandoning the learning that threatens the true spiritual dimension, he explained the subtlety of the Buddhist doctrine in a simple, vibrant, and visual language. He sang about the landscapes of Tibet, which, in their beauty and profound desolation, evoked for him the grandeur of the Buddha's teaching. Milarepa thus suggested the immense joy full of humor that naturally emerges when we finally give a place to dharma.

Milarepa is recognizable by his right hand held against his ear. This gesture indicates that he's listening to the pure intuition that springs from his meditation.

What lesson does Milarepa offer us?

Whatever your faults or the mistakes you've made, it's always possible to transform your heart. This lesson is very surprising. Indeed, when we've done something stupid, we tend to blame ourselves for the rest of our lives and carry it on our shoulders, unless we pretend that it isn't our fault.

Both these attitudes are not right.

If Buddhist tradition asks us to fully experience the seriousness of our actions and their consequences, it also asks us to transform ourselves through the strength of remorse and practice. May the power of our regret allow us to no longer commit the same faults and to become a source of peace after having been the source of suffering.

The most famous person who practiced the Buddhist tradition was a criminal! Isn't that incredible? If he succeeded in transforming such negative circumstances, we too can successfully take such a path.

Of course, just because we have the power of regret and the commitment to transform ourselves doesn't mean that justice shouldn't play its role. But, if men have the right to condemn a criminal, this does not mean that the criminal will not be able to transform himself, either.

Silk painting, Tibet, 18th–19th century

On the importance of study

Tsongkhapa was one of the great reformers of Buddhism in Tibet, at a time when the Buddha's teaching seemed to be lost in rituals so complex it was pushing many Tibetans to return to the cult of natural divinities and to superstition. For Tsongkhapa, it was important to return to a form of clear and rigorous morality. He therefore set up strict monastic rules and founded the Gelugpa order, also called the Yellow Hat order, after the color of the monks' headdress.

The hats of the first Buddhist scholars were yellow like the monks' robes, a color evoking the earth and its stability. From the seventh century onward, and facing the strong resurgence of Hindu philosophers who often had the upper hand in debates, the Buddhist orators adopted red hats, the color of fire and eloquence, which, from then on, seemed necessary for them to display. Red was considered the monastic color in Tibet.

By adopting the yellow hat, Tsongkhapa was stating his desire to return to the monks' origins.

What lesson does Tsongkhapa offer us?

If you wish to enter deeply into the practice, you will need to study. This statement may be surprising, because we tend to set meditation against study, the former being considered a practice as opposed to a theory.

In Buddhism, this opposition doesn't exist. Study is a living experience, as is meditation, and meditation should be an exercise in intelligence, as is study. It is therefore essential to link them together.

If study is so important, it's because our thoughts condition our existence much more than we think. It's what we believe that determines our way of seeing things, our actions, and our decisions.

Therefore, if you believe that man is biologically determined, you wouldn't act each day in the same manner as if you believed the meaning of your existence was constantly evolving. And, if you think you should permanently remain in control to prevent your basest instincts from taking over, you wouldn't live in the same way as if you thought that, by exercising benevolence and trust, brutality would cease.

The difficulty is that study, in our experience, is considered an intellectual, theoretical, and scholarly exercise. We don't realize that it's an adventure that opens us to the world in an unexpected and vibrant way. This is why it is so beneficial to study after having meditated.

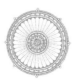

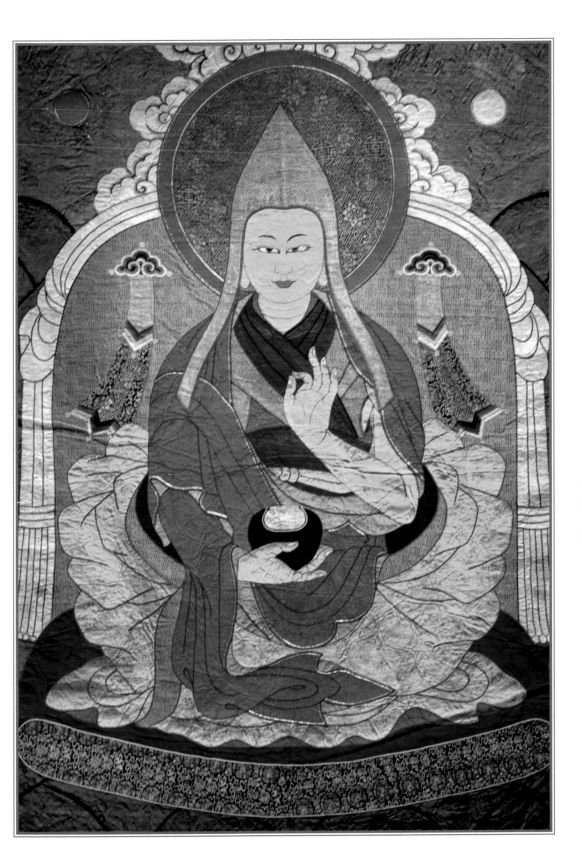

Meditation and creative imagination

The Fifth Dalai Lama lived in the seventeenth century at the time of Louis XIV. He was one of the great spiritual and temporal leaders of Tibet. Until then, Tibet had been ruled by a multitude of lords in conflict with each other.

The Great Fifth, as he is often called, succeeded in unifying the country. He formed the government of Tibet, the structure of which was preserved until 1959, established the capital at Lhasa, and had the Potala built to be his residence.

The Fifth Dalai Lama was also a great writer and visionary. His body of work is made up of around twenty-seven volumes. He also recorded in writing the numerous visions he had seen during his life, going right back to when he was six years old. These visions came to the Great Fifth when he was alone in his private apartments or while on retreat, and were kept secret for a long time due to their being censured by the religious institutions.

He understood that the study of Buddhist doctrine alone, as complex and precise as it was, was not sufficient to attain spiritual realization. In order to reach this, study had to be blended with deeper practices and much greater trust.

The Fifth Dalai Lama thus succeeded in uniting within hismself several dimensions—a highly ambitious political dimension, Tsongkhapa's intellectual and moral rigor (being his heir), and the most intense mysticism. At the Great Fifth's death, his regent, wanting to finish his work at the Potala in accordance with the Dalai Lama's directives, hid his passing from the Tibetan people for more than twelve years, pretending that he was in retirement.

What lesson does the Fifth Dalai Lama offer us?

Meditation can lead to an incredible visionary and prophetic experience. This is an important lesson. Indeed, we tend to identify the practice with the here and now, which is understood in a rather narrow sense. I'm here, and I simply feel what is.

In truth, while we're in the present, we may feel a great flash capable of shaking up our concept of true time and opening us up to a more expansive experience.

In a radio program I took part in, some children were questioning experts. One of them asked this question: "Why is it that, when I'm playing, time passes more quickly?" This is a very profound question and highlights a phenomenon to which we don't often pay enough attention. True time is not what we measure with our watch. True time is connected to presence and how we inhabit it.

When I first began practicing, I believed it was necessary to put our imagination aside so as not to leave the here and now. I gradually understood my error. True time is time where we cease to exercise all control, where we abandon ourselves to what is, where we learn, in a manner of speaking, to dance. It's often the poets and visionaries like Rimbaud and Van Gogh who were most successful in showing us this sense of expansive reality.

Mongolia, 19th century

An awakened society

The prince Shotoku is often called the "Buddha of Japan." For his time, he had an exceptional knowledge of Chinese literature and Buddhist writings.

Son of the emperor Yomei, Shotoku was occupied from very early on in the battle against the Nakatomi (the court's Shinto priests), the Monobe (warriors who favored native beliefs), and the Soga (followers of the new Buddhist religion that he was trying to favor).

After a long period, the Soga, who Shotoku had supported, triumphed. In recognition of his support, the young imperial prince was named regent at the age of nineteen. A gifted scholar, he declared Buddhism the state religion, which allowed for its lasting dissemination within Japan. He reorganized the nobility of the court and enacted his "Constitution in seventeen articles" to include numerous Buddhist aspects. He proclaimed: "With all your heart, worship the treasures that are the Buddha, the dharma, and the sangha, because you will find in them the ideal life and the country's wisdom.... We cannot hope to straighten man's tortuous paths without the help of these three jewels."

What is Shotoku's lesson?

Buddhism must be able to inspire political commitment. We sometimes mistakenly separate the practice, which concerns the private sphere, and the practical tasks of life taken care of by social and political organization. This vision is too limited.

Through his commitment to the Buddha, Shotoku found a way to respond to the adversity of his time and to work toward major social and cultural renewal. We owe to him, for example, recruitment for important public positions based on merit rather than in accordance with heredity, the development of the arts, and efforts to prevent the suffering of the population as well as animals.

In today's world, is the only possible political plan to promote economic growth, free trade, and security? Is this enough for people to live together? Shouldn't we rather be working toward the awakening all of society by promoting full presence and benevolent love?

Japan, 19th century

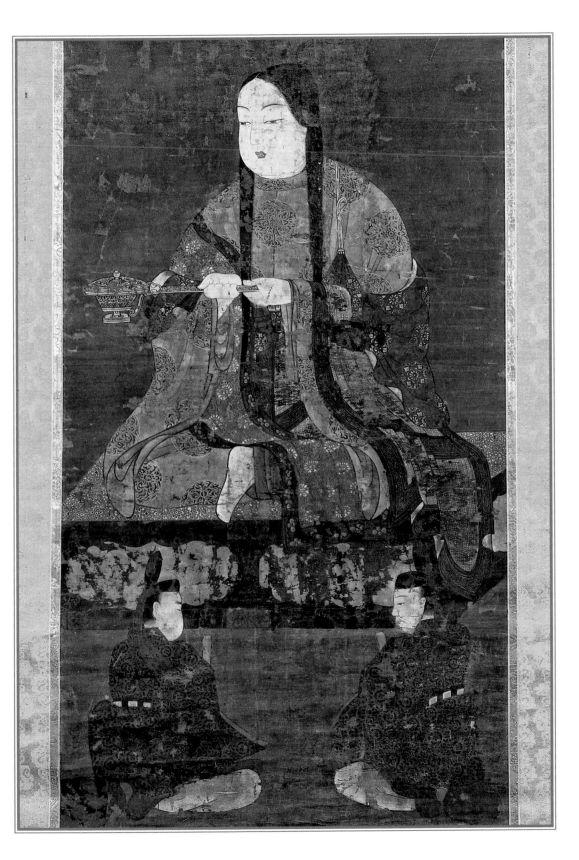

Don't separate meditation from your life

Kankaripa is one of the eighty-four Mahasiddhas, the Great Adepts of the Indian tradition. The Great Adepts live by freeing themselves from the weight of social conventions, which smother the authentic spiritual flame. They choose to live in places considered impure and care nothing for honor. Their only concern is the intensity of the commitment to meditate, and not the distinctions of sex, age, caste, or social status. They often choose to link their practice to their everyday activities, as they progress along the Buddha's Way. They believe that any activity can be an opportunity for enlightenment. We find among them people who practice while being engaged in all sorts of occupations—beggars or kings....

Kankaripa was a servant. When his wife, who he loved passionately, died, he was gripped with profound despair. He remained next to the body, unable to tear himself away. An itinerant master then said to him: "Why be distressed? The culmination of birth is death. All composite things are impermanent. What good can it do to keep a cadaver like a stone? Reject suffering instead by practicing the doctrine."

Wild with grief, Kankaripa asked him how to do this. The master gave him instructions: "Reject the preoccupation with your dead wife and meditate on your spouse in a nonegoistic mind and in the union of bliss and emptiness." At the end of six years of this practice, the concept of an ordinary spouse disappeared and Kankaripa was liberated. He had passed from an ordinary spouse to an extraordinary spouse—pure bliss.

What lesson does the tradition of yogis offer us?

All people who practice meditation and walk in the Buddha's footsteps are in some way a yogi. Indeed, we look to connect our meditative commitment to our daily life, and to our professional and family commitments. We cannot take the path by adopting a monastic way.

According to the prevailing pattern in Asia, the path of practice was reserved for monks. Laypeople were supposed to support this practice, in particular by ensuring their survival. Such deserving actions would allow them much later, in other lives, to devote themselves to the path. But the tradition of the yogis shows us that it's possible to practice meditation in a profound way in the very heart of our existence. This way of life may even be better than that of the monks. Naturally, they present many difficulties—how to practice when overwhelmed with work, when we have money problems, or when we discover that our spouse has been unfaithful—but these difficulties also allow us not to cocoon ourselves in a comfort zone, and let us open up even more.

Mural painting, Hemis Monastery, Ladakh, India, 17th century

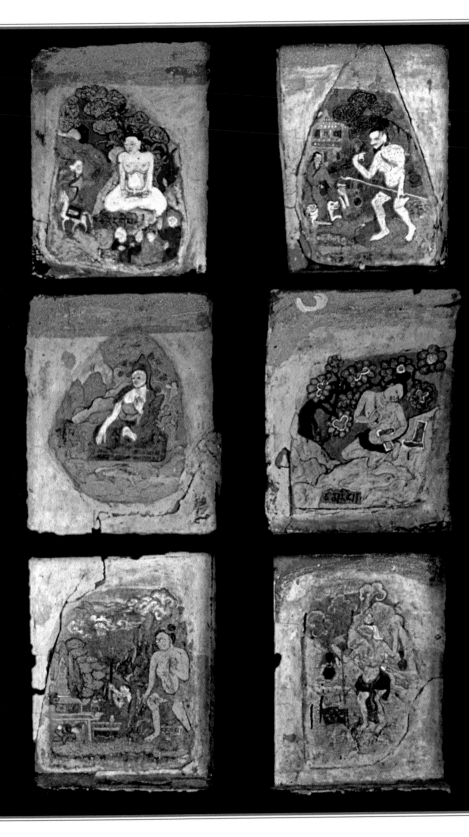

Become your own master

Lin-Chi was born in China under the Tang dynasty, in the ninth century of our era, and established at the heart of the Way an attitude of joyous indifference and nonconformism. He is well known for his abrupt and sometimes provocative manner of speaking.

One of the decisive points of his teaching is to practice by abandoning all thought of obtaining something from it. Of course, anyone who practices does this hoping that this will help them suffer less or acquire new skills. But the instant you expect something or wish for this to happen, you are no longer truly practicing, because the very meaning of meditation consists of opening ourselves up unconditionally to reality just as it is.

In other words, the more you search for something in the practice—peace, enlightenment, calmness—the more you distance yourself from the practice. The meaning of meditation does not comprise searching for something from elsewhere, because then you are distancing yourself from your own abode. Simply have confidence in the present situation.

This is the meaning of Chan, which eventually gave Zen to Japan—terms that both signify "meditation." Lin-Chi is considered one of the figures of this tradition. His concern to prevent all searching of peace outside oneself led him to ask his disciples to forget what he told them.

Stop humiliating yourself by saying: "He's a wise man, a saint, and I'm a confused and ordinary being." Be your own master in all circumstances. Do not search outside for what you have in your own home. Isn't this a healthy lesson for today?

What lesson can we take from Lin-Chi?

We miss the essential things. The one who believes he's good at his practice goes astray. He loses the right spontaneity, becomes an expert, and is no longer free.

To get someone interested in the Way, explains Lin-Chi in a famous text, I go toward him. He doesn't recognize me. "So I wear all sorts of clothes, which produce interpretations in the apprentice, and, suddenly, he lets himself be taken by my words and phrases. Oh bitterness! These blind, shorn men, these men who do not have the eye, take the garments I've worn and see me as blue, yellow, red, white. And if I take them off to approach pure realms, suddenly these apprentices also want to aspire to purity; and if I again take off this garment of purity, they are now lost and shocked. They start running like fools, saying I am naked! So I say to them: 'Do you now recognize *the man* in me who wears the garments?' And suddenly they turn their head and then they know me."

What better way to show that the meaning of the practice is not about playing a role, even if it's virtuous, but in becoming an "ordinary" and "simple" being.

Ink on paper, Japan, 18th century

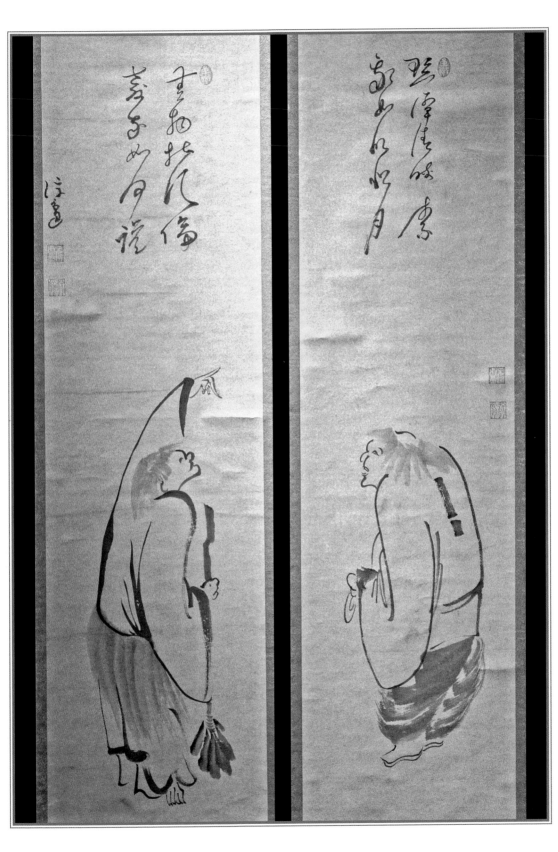

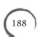
The art of insignificant things

Muso Soseki (1275–1351) is a famous Zen master who, in his lifetime, received the title of national master from the emperor Go-Daigo.

After having practiced in several Buddhist schools, he committed himself to Zen, because he saw in it "a unique transmission across the writings." In solitary retreat, while he was diligently practicing meditation, he wanted to lean against a nonexistent wall and fell. He burst out laughing: the obstacles he had pushed against so much had crumbled.

He remained in solitude for another seventeen years, before, in 1325, accepting to become the head priest of Nanzen-ji, one of Kyoto's most important monasteries. We owe him the *Muchû Mondô*, "Questions and answers in a dream," one of the great texts of the Zen tradition. He is also known for being one of the first authors on Zen gardens, one of which is the moss temple of Saiho-ji. On one of its walls he engraved this inscription:

> *Those who are detached from the world taste the calm of the mountains,*
> *The wise naturally love the purity of the water.*
> *By playing with the landscape and the stream of water,*
> *I aim only to refine its purity.*

<div align="center">Muso Soseki</div>

What lesson does Soseki offer us?

In Japan, the aim of art isn't—as it often is in the West—to create masterpieces. It's a way of being that expresses the great principles of meditation. An "art" therefore developed for making tea, shooting arrows, arranging flowers in a vase, creating calligraphy, or planting a garden.

No superiority is accorded to painting over the art of tea-making, even if the latter doesn't produce a tangible piece of work. I find this vision very inspiring. It's a way not to separate meditation from action, the sacred from the profane. Each gesture that I make, every activity in which I engage, can allow me to extend my practice.

We could therefore put away our clothes, or prepare a cup of coffee or a meal, not as if it were a chore, in a somewhat mechanical manner, but by putting our whole heart into it. As a first step, let's all try, for example, to liven up one activity of our choice each day.

Kamakura, Japan, 14th century

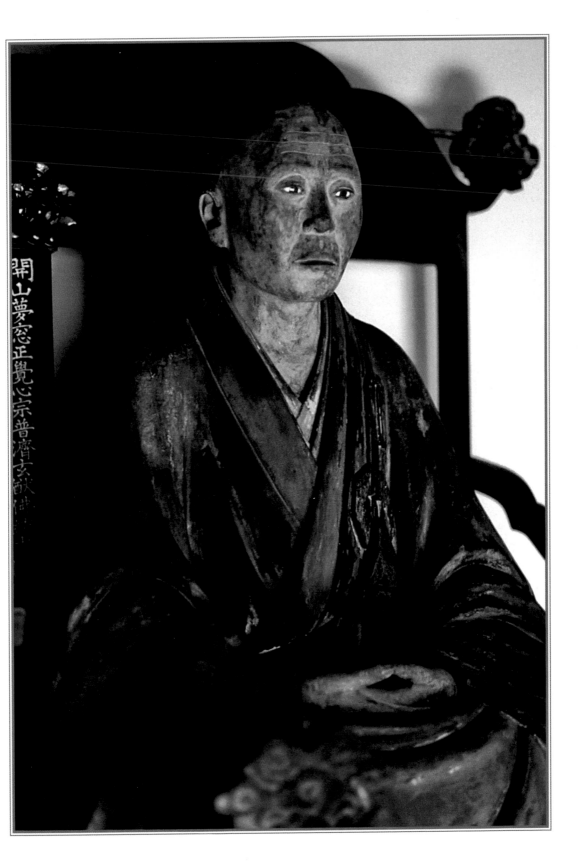

Index

Acknowledgments

Picture credits

p. 2 ©akg-images / Werner Forman; p. 12 ©akg-images / De Agostini Picture Lib. / G. Dagli Orti; pp. 15, 23 ©Roland and Sabrina Michaud / akg-images; p. 25 ©akg-images / Erich Lessing; pp. 26, 27 ©akg-images / De Agostini Picture Lib. / G. Dagli Orti; p. 29 ©akg-images / Erich Lessing; p. 31 ©akg-images / Alfons Rath; p. 33 ©akg-images / Gilles Mermet; p. 34 ©akg-images / De Agostini Picture Lib. / G. Dagli Orti; p. 35 ©Roland and Sabrina Michaud / akg-images ; p. 37 ©akg-images / Gilles Mermet ; p. 38 ©akg-images / Nimatallah; pp. 39, 41 ©Roland and Sabrina Michaud / akg-images; pp. 43, 44 ©akg-images / Jean-Louis Nou; p. 47 ©akg-images; p. 48 ©akg-images / Gilles Mermet; p. 51 ©akg-images / CDA / Guillemot; pp. 53, 55 ©akg-images / Erich Lessing; p. 57 ©akg-images; p. 59 ©akg-images / Erich Lessing; p. 61 ©akg- images / Jean-Louis Nou; p. 63 ©akg-images / Universal Images Group / Pascal Deloche / GODONG; p. 65 ©akg-images / Album / Prisma; p. 66 ©Yvan Travert / akg-images; p. 69 ©akg-images / Erich Lessing; p. 71 ©akg-images / Gilles Mermet; pp. 72, 73 ©akg-images / Gerard Degeorge; p. 74, ©akg-images / De Agostini Picture Lib. / C. Rives; p. 75 ©akg-images / Alfons Rath / Bildagentur Rath— Luftbildservice; p. 77 ©Roland and Sabrina Michaud / akg-images; p. 79 ©akg-images / De Agostini Picture Lib. / G. Dagli Orti; pp. 81, 83 ©akg-images; p. 85 ©akg-images / Jean-Louis Nou; p. 87 ©akg-images / Erich Lessing; p. 89 ©Roland and Sabrina Michaud / akg-images; pp. 90, 97 ©akg-images / De Agostini Picture Lib. / G. Dagli Orti; p. 98 ©akg-images / François Guénet; p. 101 ©akg-images / Pictures From History; p. 102 ©akg-images / De Agostini Picture Lib. / G. Dagli Orti; p. 103 ©Roland and Sabrina Michaud / akg-images; p. 105 ©akg-images / Jean-Louis Nou; p. 106 ©Monique Pietri / akg-images; p. 109 ©akg-images / Pictures From History; p. 111 ©akg-images / Erich Lessing; p. 113 ©akg-images / De Agostini Picture Lib. / G. Dagli Orti; pp. 115, 116 ©akg-images; p. 119 ©akg-images / Suzanne Held; p. 121 ©akg-images / Pictures From History; pp. 123, 125 ©akg-images / De Agostini Picture Lib. / G. Dagli Orti; pp. 126, 127 ©akg-images / Erich Lessing; p. 129 ©akg / Bildarchiv Steffens; pp. 131, 133 ©akg-images / Pictures From History; p. 139 ©RMN-Grand Palais (musée Guimet, Paris) / Thierry Ollivier; p. 141 ©akg-images; p. 142 ©akg-images / Werner Forman; p. 143 ©Roland and Sabrina Michaud / akg-images; p. 145 ©akg-images / Erich Lessing; p. 146 ©akg- images / Werner Forman; p. 149 ©akg-images / De Agostini Picture Lib. / G. Dagli Orti; p. 151 ©akg-images / Pictures From History; p. 153 ©akg-images / Jean-Louis Nou; p. 154 ©Roland and Sabrina Michaud / akg-images; p. 155 ©akg-images; p. 156 ©Roland and Sabrina Michaud / akg-images; p. 157 and front cover ©akg-images / Album / Prisma; p. 158 ©Roland and Sabrina Michaud / akg-images; p. 159 ©akg-images / Erich Lessing; p. 161 ©akg-images / Bruce Connolly; p. 163 ©IAM / akg-images / World History Archive; p. 165 ©akg-images / ullstein bild; pp. 171, 173, 175 ©akg-images / Erich Lessing; p. 177 ©akg-images / De Agostini Picture Lib. / G. Dagli Orti; p. 179 ©akg-images; p. 181 ©akg-images / Pictures From History; p. 183 ©akg-images / Erich Lessing; p. 185 ©akg-images / Jean-Louis Nou; p. 187 ©akg-images (both); p. 189 ©akg-images / Werner Forman

Illustrations on pages 19, 93, 135, 167 by Chao-Hsiu Chen

Symbol illustrations (throughout) by Robert Beer